# 50 FINDS FROM NOTTINGHAMSHIRE AND DERBYSHIRE

## Objects from the Portable Antiquities Scheme

Alastair Willis

AMBERLEY

First published 2016

Amberley Publishing
The Hill, Stroud
Gloucestershire, GL5 4EP

www.amberley-books.com

Copyright © Alastair Willis, 2016

The right of Alastair Willis to be identified as the
Author of this work has been asserted in accordance
with the Copyrights, Designs and Patents Act 1988.

ISBN 978 1 4456 5853 7 (print)
ISBN 978 1 4456 5854 4 (ebook)

British Library Cataloguing in Publication Data.
A catalogue record for this book is available from
the British Library.

Typeset in 10pt on 13pt Celeste.
Typesetting by Amberley Publishing.
Printed in the UK.

# Contents

# Acknowledgements

This book has been made possible by the combined efforts of past and present Finds Liaison Officers since 1997, particularly my predecessors Rachel Atherton, Anja Rohde and Charlotte Burrill. I would like to thank all the staff at Derby Museums Trust, especially Jonathan Wallis and Tony Butler, as well as Nottingham City Museums and Galleries and the University of Nottingham Museum, for supporting and facilitating the Portable Antiquities Scheme. I would also like to thank Michael Lewis and other colleagues within the PAS and at the British Museum, including Adam Daubney, Katie Hinds and Richard Henry, for their ongoing support and for preparing me for my current role, as well as the volunteers who give up their free time to assist me with recording finds. I am also grateful to my parents, Patrick and Caroline, for supporting me during my own time as a volunteer, which gave me the experience necessary for my role as FLO. Thank you to Richard Davis, Neil Wilkin, Sophia Adams, Sally Worrell, Sam Moorhead and Matt Beresford for their insights into some of the objects featured here. Special thanks go to Lucy Young for all her support throughout, and to Lucy, Rachel Atherton and Olivia Webster for taking the time to read through and contribute their thoughts to this book. And a final thanks to everyone who brings in their objects for recording, which are so important for advancing our knowledge of the past.

All object images are courtesy of the Portable Antiquities Scheme unless otherwise stated. All other photographs were taken by the author unless otherwise stated. Thank you to David Williams, Lucy Young, the National Civil War Centre – Newark Museum and Creswell Heritage Trust for providing me with the other images. The maps (unless otherwise stated) were created using QGIS (QGIS Development Team, 2016. QGIS Geographic Information System. Open Source Geospatial Foundation Project. www.qgis. org). Every attempt has been made to seek permission for copyright material used in this book. However, if we have inadvertently used copyright material without permission/acknowledgement we apologise and we will make the necessary· correction at the first opportunity. Unless otherwise stated, all objects were returned to their finders.

# Foreword

The places in which we live and work have a long past, but one that is not always obvious in the landscape around us. This is a forgotten past. Most of us know little about the people who once lived in our communities fifty years ago, let alone 500, or even 5000 years past. Like us, they lived, played and worked here, in this place, but we know almost nothing of them ...

History books tell us about royalty, great lords and important churchmen, but most others are forgotten by time. The only evidence for many of these people is the objects that they left behind; sometimes buried on purpose, but more often lost by chance. Occasionally, through archaeological fieldwork, we can place these objects in a context that allows us to understand the past better, but nowadays excavation is mostly development led, so only takes place when a new building, road or service pipe, is being constructed.

A unique way of understanding the past is through the finds recorded through the Portable Antiquities Scheme, of which those chosen here by Alastair Willis (Finds Liaison Officer for Derbyshire & Nottinghamshire) are just fifty of over 14,000 from Derbyshire and Nottinghamshire on its database (www.finds.org.uk). These finds are all discovered by the public, most by metal-detector users, searching in places archaeologists are unlikely to go or otherwise excavate. As such they provide important clues of underlying archaeology that (once recorded) help archaeologists understand our past – a past of the people, found by the people.

Some of these finds are truly magnificent, others less imposing. Yet, like pieces in a jigsaw puzzle they are often meaningless alone, but once placed together paint a picture. These finds therefore allow us to understand the story of people who once lived here, in Derbyshire and Nottinghamshire.

Dr Michael Lewis
Head of Portable Antiquities & Treasure
British Museum

# Introduction

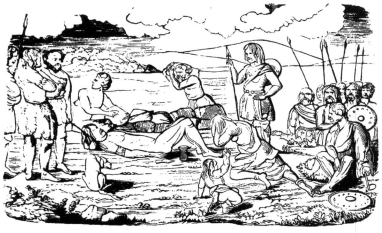

BURIAL OF THE ANCIENT BRITONS.

'Burial of the Ancient Britons'. An antiquarian's interpretation of the past. (Howarth, 1899)

Interest in the history and archaeology of Nottinghamshire can be traced back to the late seventeenth century, when antiquarian Dr Robert Thoroton wrote *Antiquities of Nottinghamshire*, a history of the county focusing on the heraldry he found in churches in the southern part of Nottinghamshire. The county's main archaeological society is named after him. In Derbyshire, the most prominent antiquarian was Thomas Bateman, who excavated more than a hundred barrows in Derbyshire in the mid-nineteenth century and assembled a large collection of artefacts, now housed by Weston Park Museum in Sheffield. He also wrote *Vestiges of the Antiquities of Derbyshire* (1848), *and the Sepulchral Usages of Its Inhabitants: From the Most Remote Ages to the Reformation*. He is a controversial figure, due to the speed at which he excavated the barrows; however, unlike many of his contemporaries, he kept records of the excavations and the objects he discovered, and arguably saved them from being robbed by treasure hunters.

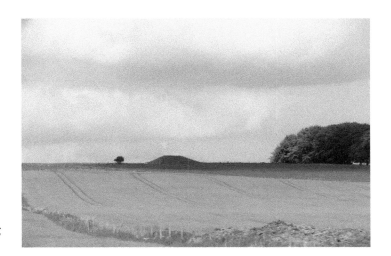

Gib Hill, one of many barrows in Derbyshire excavated by Thomas Bateman. (© Lucy Young 2016)

'Section of Parcelly Barrow', possibly by Thomas Bateman (Howarth, 1899, p. 7).

By the nineteenth century, many ancient sites had been flattened to make space for farmland, or had been robbed for their stone. Destruction of ancient sites was taking place across the country, but a group of archaeologists, led by John Lubbock, were battling to save them. Eventually, in 1882, the Ancient Monuments Protection Act was passed, an Inspector of Ancient Monuments was appointed, and sixty-eight sites across Britain and Ireland were 'scheduled' (meaning they were protected). Four of these were in Derbyshire: Arbor Low, Hob Hurst's House, Minning Low and Nine Ladies Stone Circle. Many archaeologically significant sites in both counties are now protected by scheduling and by stewardship schemes.

A metal-detecting rally. (© David Williams).

The invention of metal detectors presented archaeologists with a potentially useful tool for studying the past, but many archaeologists were initially dismissive of metal-detected finds, believing that, once out of the ground and their context, these objects were of little archaeological value. Others saw that responsible metal detecting could be invaluable for locating and analysing sites, especially those destroyed by ploughing. However, there was no national organisation to record the objects that metal detectorists were finding, the vast majority of which were disappearing into private collections, leaving no trace of their existence. Lots of potentially vital information was being lost. Recognising the issue, Roger Bland formed the Portable Antiquities Scheme in 1997 to record objects found by members of the public so that these finds could contribute to our understanding of the past. When the PAS was formed, it initially only covered a few counties. It was eventually rolled out over the whole of England and Wales, and the first Finds Liaison Officer for Derbyshire and Nottinghamshire, Rachel Atherton, was appointed in 2004. Since the creation of the PAS database in 1999, more than 12,800 objects have been recorded from Nottinghamshire and more than 6,900 from Derbyshire, in a combined total of over 14,000 records.

### The archaeology and landscape of Derbyshire and Nottinghamshire

It is often said by archaeologists that the East Midlands are a microcosm of the whole country, featuring all of Britain's main landscape types. Derbyshire and Nottinghamshire are a very important part of this microcosm, as many of their landscape features – in particular the highlands of the Peak District and the major river valley of the Trent – are not represented in the other counties of the East Midlands.

The Peak District lies in the north-west of Derbyshire. The areas immediately to the south and east are hilly but, further away, the land becomes gradually lower and much flatter. The hills of the Peak District are rich in sources of lead and coal, but are unsuitable for growing crops, and are mostly given over to pasture. By contrast, the lowlands of Nottinghamshire are ideal for arable farming, and have been heavily farmed since the Roman period.

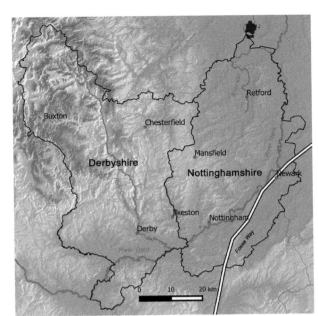

Map of Derbyshire and Nottinghamshire showing their topography, major towns and rivers and the Fosse Way. (Contains OS data © Crown copyright and database right (2016))

Hills of High Peak in north-west Derbyshire.

The Trent Valley near Newark.

Farmland along the banks of the Trent.

The other major landscape feature is the River Trent, which further emphasises the division between the highlands and the lowlands. The archaeology of different parts of Derbyshire and Nottinghamshire is defined by these landscape features in a number of important ways.

Firstly, rates of archaeological survival differ across the region. Centuries of intensive ploughing in the south and east of the region has resulted in many sites being damaged or destroyed. By contrast, many of the sites in the pastoral lands of north-west Derbyshire have survived undisturbed.

Secondly, discovery of sites and artefacts is also affected by the landscape. Archaeological excavation, where context is vital for dating sites, is more likely to be successful on undisturbed pasture, where archaeological features (embankments, walls, etc.) are more likely to survive. By contrast, metal detecting is generally considered more effective on cultivated land, as ploughing brings objects closer to the surface. Furthermore, the Code of Practice for Responsible Metal Detecting advises that metal detectorists stick to ploughed land, so as to avoid damaging any *in situ* archaeology. The ban on metal detecting in the Peak District National Park is also a significant factor.

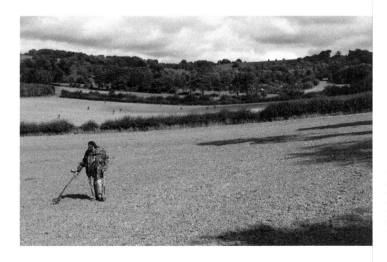

Responsible metal detecting on ploughed land can be very useful for increasing our knowledge of the past. (© David Williams)

Thirdly, the landscape has affected the rate of loss or deposition of objects in the past. The arable lowlands in the south and east would have been able to support higher population levels and larger settlements than the pastoral highlands. Moreover, the inhabitants of the lowlands appear to have produced more material culture per person than those of the Peak District. The vicinity of these lands to the River Trent was also a highly significant factor, because, from prehistoric times until the creation of the railways, it acted as the main high road and trade route for the local population. As a result, there was a lot more human activity around the Trent and its tributaries than in other parts of the two counties. The exploitation of the area's other natural resources of lead and coal at various times meant that the populations of different areas fluctuated, especially during the Industrial Revolution, when many people moved from the countryside to industrial or mining towns in search of work.

Lastly, the River Trent was a natural boundary that appears to have reinforced cultural divides, which becomes especially obvious during the Iron Age and early Roman period. As a result, the material culture of the north-west can be significantly different from that of the south-east.

As a result of these four factors, many more objects recorded on the PAS database are from Nottinghamshire than Derbyshire, and the only objects that come from the Peak District National Park are found in gardens or while hiking.

Many of the objects in this book reflect how the region forms a meeting point between the highlands and the lowlands. Others demonstrate the importance of the Trent and the Fosse Way as trade routes that connected the area to other parts of the country and the wider world.

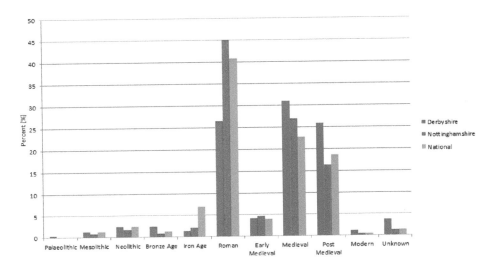

Graph comparing the percentage of objects from each period in Derbyshire, Nottinghamshire and nationally.

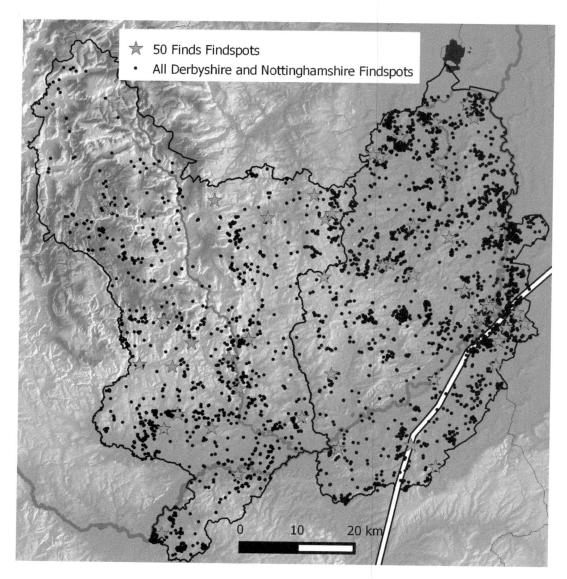

Map showing the broad locations for the finds included in this book and other finds from the two counties. (Contains OS data © Crown copyright and database right (2016))

# The Palaeolithic Period (around 800,000–10,000 BC)

Most of the last million years has been characterised by a series of cold periods (known as glacials) and warm periods (inter-glacials), which had huge effects on the human and animal species that lived in Britain and north-western Europe. Human occupation of the area was intermittent and for long periods there were no humans here as glaciers covered much of Britain; the East Midlands were at times covered by ice that was over a mile thick.

Very little is known about the humans who first lived in Britain; very few human skeletal remains dating to the Lower Palaeolithic (around 800,000–150,000 BC) have been discovered. Based on surviving remains from Britain and other parts of Europe, three different human species probably existed during this period: *Homo antecessor*, *Homo heidelbergensis* and 'pre-Neanderthals'. Evidence is very scarce from the Lower Palaeolithic because many sites were obliterated by advancing ice sheets and the landscape changes that resulted from the later meltwater. As a result, many of the objects that survive are found in the gravel deposits of rivers, many miles from where they were first deposited.

For the first 100,000 years of the Middle Palaeolithic (around 150,000–40,000 BC) there is no evidence of human activity, the extremely cold temperatures making human life impossible. As the climate warmed, a new species arrived in Britain: the Neanderthals. Much of what we know of the period comes from the limestone gorge and caves at Creswell Crags.

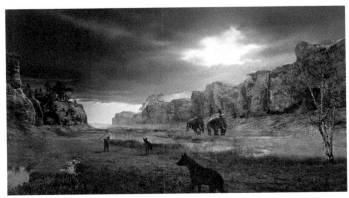

How the limestone gorge at Creswell Crags may have looked around 60,000 years ago in the Middle Palaeolithic. (© 2016 Creswell Heritage Trust)

Artist's reconstruction of Neanderthals in the caves of Creswell Crags around 50,000 years ago. (© 2016 Bob Nicholls/Creswell Heritage Trust)

The first modern humans arrived in Britain in the Upper Palaeolithic (around 40,000–10,000 BC). They interbred with Neanderthals and eventually replaced them.

The Palaeolithic Period saw the first production of stone (flint, chert and quartzite) implements, including hand axes, flakes and blades that could be converted into scrapers, and hafted tools such as spear points and cutting tools. Very few Palaeolithic tools have been recorded on the PAS database from Derbyshire or Nottinghamshire. This is probably mostly because of the destructive effects of glaciation, but may also be because Palaeolithic tools can be hard to distinguish from naturally formed rock.

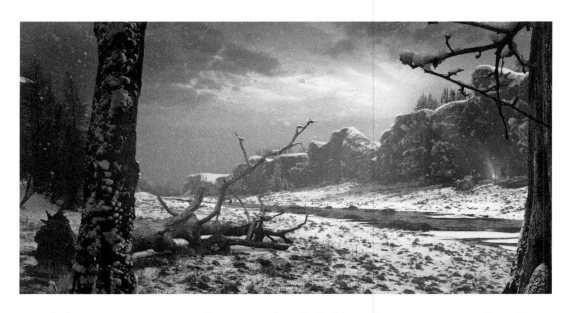

How the limestone gorge at Creswell Crags may have looked around 12,000 years ago at the end of the Palaeolithic Period. (© 2016 Creswell Heritage Trust)

**1. Acheulian hand axe (LIN-D3C064)**
Lower Palaeolithic (around 800,000–180,000 BC).
Discovered in 2009 in Langford, Nottinghamshire.

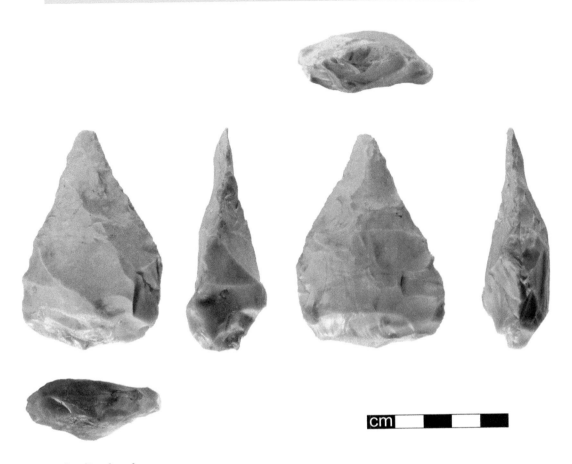

cm

Acheulian hand axe.

Creswell Crags, the site most associated with Palaeolithic finds, was not occupied until the Middle Palaeolithic (around 60,000 BC). This hand axe predates that by at least 120,000 years but possibly by as much as 740,000 – however, the later end of the period is much more likely. Hand axes like these were multi-purpose tools. As the name suggests, they were held in the hand rather than hafted onto handles. Hand axes from Nottinghamshire are normally fairly crude and irregularly shaped, as the large flint nodules that are needed to make more symmetrical oval and pointed hand axes are not common in the region. That said, this example is quite well realised, if not quite as aesthetically pleasing as some from other areas.

## 2. Ovate hand axe (DENO-DE1DA4)
Lower Palaeolithic (around 800,000–180,000 BC).
Discovered in 1985 in Mickleover, Derby.

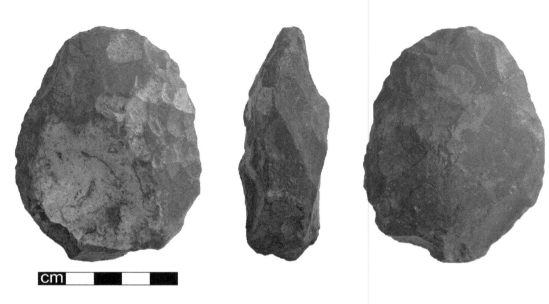

Ovate hand axe.

This flint hand axe is worn and heavily stained with iron, showing that the axe was submerged and rolled about in a river over many years. During that time it may have moved a considerable distance from where it was first deposited. Other damage appears to have been caused at a later date, as these areas are not coloured red. However, the deep patina covering these areas suggests that the damage occurred many years before its discovery in a garden in Derby.

# The Mesolithic Period (around 10,000–4,000 BC)

The start of the Mesolithic Period was marked by an increase in temperatures, which led to the ice sheets melting, resulting in a rise in sea levels and Britain's subsequent separation from the Continent. Woodland replaced the tundra of the Palaeolithic. The people who lived during this period were hunter-gatherers. They left few traces of their existence apart from scatters of flint that indicate where people were making flint tools. The waste products of knapping (debitage) are the most common finds on the PAS database from this period, but the most recognisable flint objects are microliths. These very small objects were made from small, narrow flakes called 'bladelets'; they were hafted onto weapons, such as arrows and harpoons.

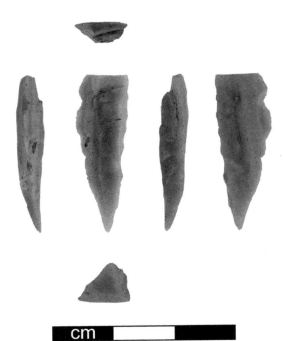

A Mesolithic microlith from Charlesworth, Derbyshire (DENO-C677C6).

### 3. Chert core (DENO-7AD544)

Mesolithic to Neolithic (around 9,000–2,200 BC).
From a collection of flint discovered over the last 30 years near Elmton, Derbyshire.
Creswell Crags Museum and Visitor Centre.

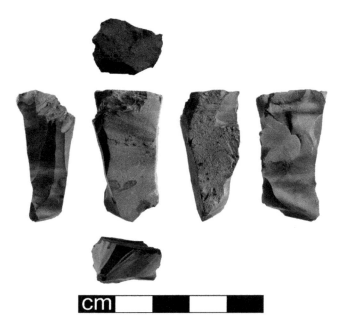

Chert core.

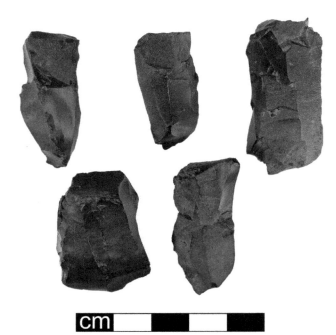

Some of the other chert cores
from Elmton. (Creswell Heritage
Trust)

Metal detectorists discover most of the objects that are recorded on the PAS, but there are also people who search for objects by field-walking, only using their eyes to spot objects lying on the surface. This method is the most productive way of finding worked flint. Worked flint takes a variety of different forms, including completed tools, cores and debitage. Debitage, consisting of flakes and 'blades' (long narrow flakes), can be further worked to make tools; this is especially true during the Mesolithic Period, when microliths were being produced from blades and bladelets. The flints that have come up from near Elmton are notable for their relatively high number of cores compared to debitage and finished tools. The lack of flakes and blades seems to indicate that these were being taken away for use elsewhere. Also interesting is that chert is not local to immediate area around Elmton and Creswell. The closest sources of chert are in the Peak District in north-west Derbyshire.

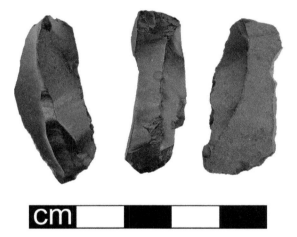

There are some blades from Elmton, but not as many as one would expect from the number of cores that have been discovered. (Creswell Heritage Trust)

Debitage produced from the chert cores from Elmton. (Creswell Heritage Trust)

# The Neolithic Period (around 4,000–2,350 BC)

The introduction of farming, both arable and pastoral, in the Neolithic Period led to major social changes as well as significant changes to the landscape. The human population increased, concentrating into recognisable, albeit small, settlements, particularly along the Trent and its tributaries. At the same time, there was a gradual clearance of the woodland that covered the lowland areas to make room for pasture and arable land. During this period, we see the first monumental structures, consisting of funerary and ceremonial enclosures such as long barrows, henges and stone circles like those at Arbor Low. The most characteristic objects from this period are polished stone axe heads, but more common are flint scrapers and arrowheads.

7

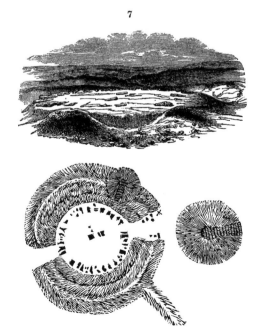

VIEW AND PLAN OF ARBORLOW.

'View and plan of Arbor Low', possibly by Thomas Bateman. (Bateman, 1855, p. 7)

**4. Polished stone axe head (DENO-5D54D4)**
Neolithic (around 3,500–2,100 BC).
Discovered in 1972 near Mansfield, Nottinghamshire.
Mansfield Museum.

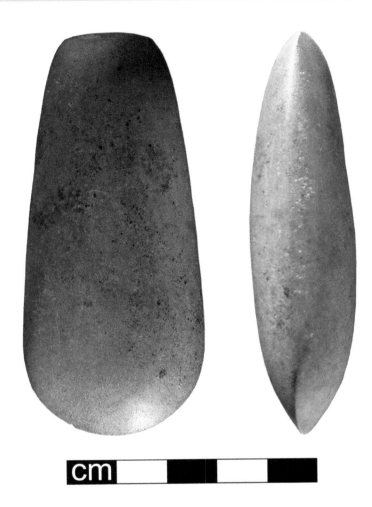

Polished stone axe head.

cm

Polished stone axes appear to have been objects of significant value during the Neolithic. They were intended to be hafted into wooden handles and then used for clearing woodland. It is thought that grinding and polishing would have taken between 5 and 40 hours, depending on the size of the axe. Polishing was used to reduce the likelihood of the axe breaking during use, but it may also have had a ritual and symbolic purpose. Some axes travelled vast distances from where they were quarried and shaped, perhaps as a result of elite gift exchange. Unused polished axes have also been found in burials and other areas associated with other ritual practices; some appear to have been 'ritually killed' (intentionally broken), a practice commonly seen later on in the Bronze Age. This particular example is in near perfect condition and does not appear to have been used.

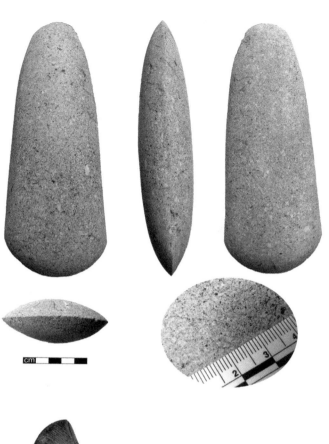

A similar polished stone axe head from Catton, Derbyshire. (PUBLIC-6B05D3)

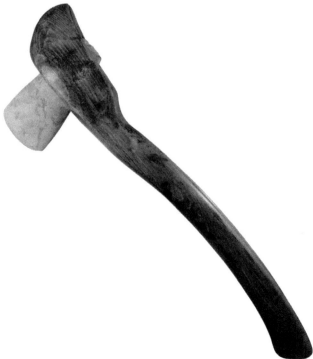

A Neolithic polished axe head, hafted into a replica handle. (Derby Museums Trust)

# The Bronze Age
# (around 2,350–800 BC)

The Early Bronze Age (around 2,350–1,500) can be seen as an extension of the Neolithic; they are often grouped together by academics. The working of metal into tools and other objects was a hugely significant step in the development of technology. However, the impact this had on the landscape and the people who lived in Derbyshire and Nottinghamshire is not immediately apparent, because people continued to build monumental structures, such as Nine Ladies Stone Circle, until the Middle Bronze Age (around 1,500–1,000 BC). From this period onwards, such funerary and ceremonial landscapes ceased to be used, settlements increased in size and density, land began to be divided up and settlements became enclosed. The most common finds from the Bronze Age are copper-alloy axes and spearheads, and flint tools and arrowheads.

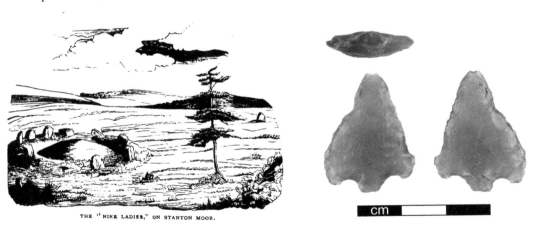

THE " NINE LADIES," ON STANTON MOOR.

*Left*: 'The "Nine Ladies," on Stanton Moor' (Howarth, 1899, p. 2)

*Right*: Flint was still being used for making arrowheads such as this one from Alkmonton, Derbyshire (LVPL-4596B3).

## 5. Migdale flat axe head (DENO-4F12EB)
Early Bronze Age (2,000–1,700 BC).
Discovered in 2015 near Wormhill, Derbyshire.
Buxton Museum and Art Gallery.

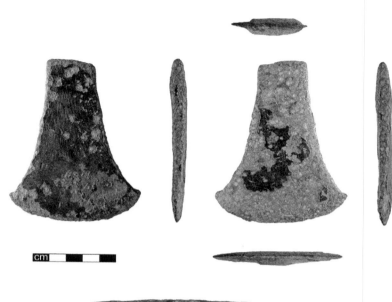

Migdale axe head.

The rain pattern
decoration is more
easily seen from
an angle.

Copper-alloy flat axes are among the earliest metal tools to have been used by our ancestors. They would have been expensive and time consuming to make, so many tools and weapons were still being made from flint and other stone. This particular type of axe is known as a Migdale type, named after Loch Migdale in the highlands of Scotland. Migdale axes are generally restricted to Scotland and the north-west of England and Wales, which suggests that there was a cultural distinction between people living in the highlands of the north-west of Britain and those living in the lowlands of the south-east. Although this axe head is incomplete and much of its patina has been lost, we can still see patches of rain pattern decoration across parts of its surface. The decoration reveals that such objects were prized possessions that would have taken a significant amount of time and effort to make and embellish.

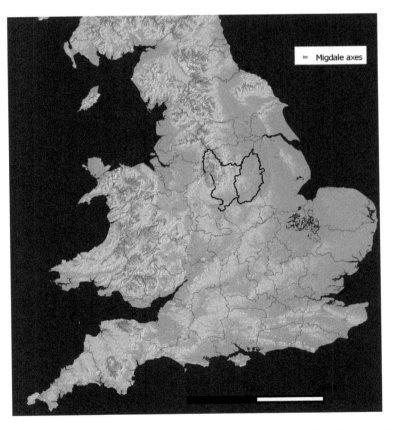 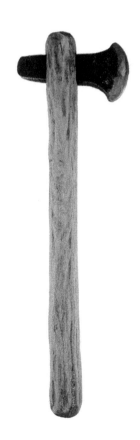

*Above left*: Map showing findspots of Migdale axe heads in England and Wales. (Contains OS data © Crown copyright and database right (2016))

*Above right*: A replica showing how the earliest flat axes were hafted in the same way as stone axes. (courtesy of Derby Museums Trust)

## 6. Flanged axe head (SWYOR-A54EF8)
Middle Bronze Age (around 1,400–1,300 BC).
Discovered in 2012 near Elmton, Derbyshire.

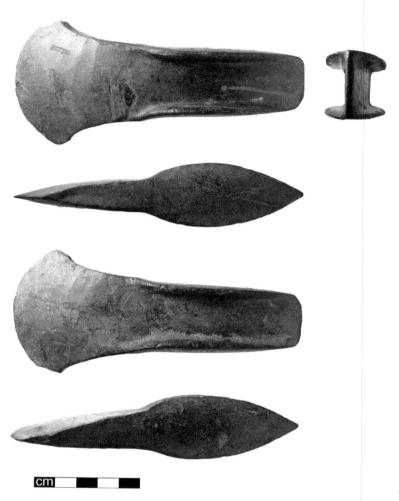

Flanged axe head.

The flanged axe head was an important step in the development of copper-alloy Bronze Age tools. Flanged axe heads are essentially flat axes with raised edges (flanges) on either side of the butt. These flanges ensured that the axe head was fitted securely onto the handle. Flanged axe heads were cast in a one-piece mould, and then the flanges were formed by hammering. Hammering was also used to shape the blade, and hammer marks can be seen on the surface of this example.

**7. Palstave axe head (DENO-A24823)**
Middle Bronze Age (around 1,300–1,100 BC).
Discovered in 2009 near Brassington, Derbyshire.
Buxton Museum and Art Gallery.

The next major development in Bronze Age tools was the palstave axe, which was essentially an evolved flanged axe. This example is made of lead, and not copper-alloy as is normally the case. Lead is a soft metal that is unsuitable on its own for making tools. It has therefore been suggested that this object was an ingot, made as a means of storing or transporting lead. However, it has also been suggested that it may have been used as a pattern for creating two-piece clay moulds for making copper-alloy axes. Also, this lead axe, being easier to make than a copper-alloy one, may have also been deposited as a votive offering.

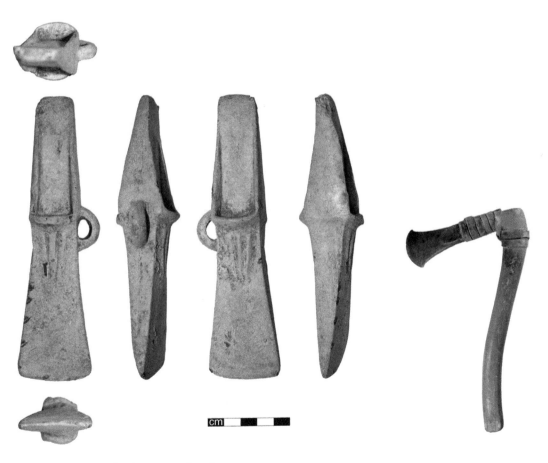

*Above left*: Lead palstave axe head.

*Above right*: Replica of a hafted palstave axe. (Derby Museums Trust)

## 8. Penannular ring (DENO-A13440)
Middle Bronze Age (around 1,300–1,100 BC).
Discovered between 1982 and 1985 near Barton in Fabis, Nottinghamshire.

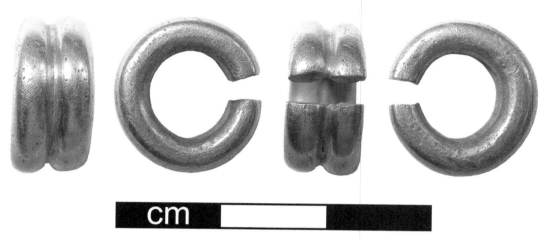

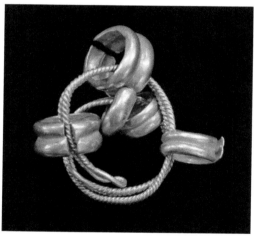

*Above*: Gold penannular ring.

*Left*: A group of gold penannular rings threaded onto a gold bracelet found near Windsor (BERK-A5FFE5).

Gold was one of the earliest metals to be worked. The earliest known gold in this country was discovered with the Amesbury Archer (around 2,300 BC). This penannular ring is 1,000 years later in date. Such rings have been found in hoards, threaded onto gold torcs and bracelets, and as single finds. Some of these may have been hair decorations, but some people believe gold penannular rings and copper-alloy rings were exchanged as a proto-currency and, as a result, they are often referred to as 'ring money'. However, with no written records to support this theory, it is impossible to know whether they were used as such or were simply jewellery.

This Late Bronze Age copper-alloy spearhead is of a type almost exclusively found in the south-east of the country and suggests trade links between that region and the Trent Valley. This type is unusual because of its short length, splayed socket and the peg holes around its socket, which would have been used to attach it to the spear shaft. This spearhead also has four holes instead of the usual one or two, making it even more unusual. Richard Davis, an expert on Bronze Age spearheads, suggests that longer types of spearhead were used by the wealthy elite, whereas lower-ranked warriors would have been equipped with mass-produced spears with fire-hardened wooden points. Short spearheads with splayed sockets like this example may form a middle ground, perhaps used by slightly wealthier individuals, but still more easily mass-produced than other types of spearhead.

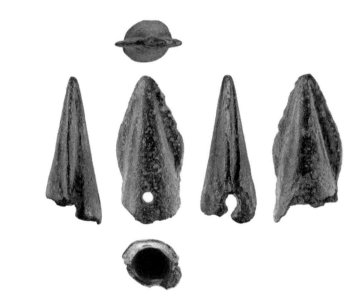

Spearhead.

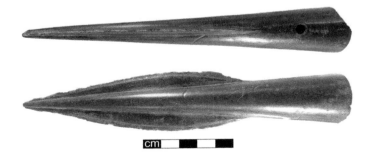

A more typical socketed spearhead of the period.

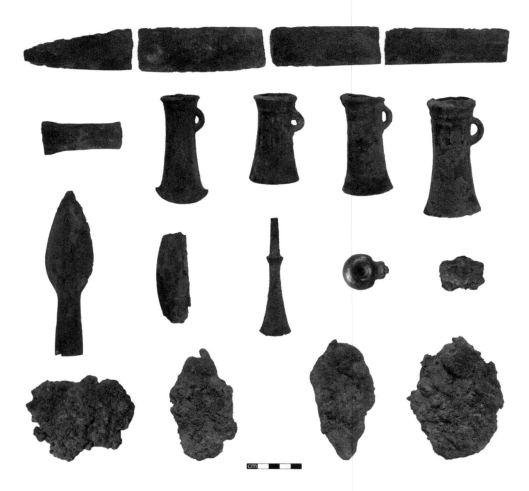

The Tuxford Hoard.

Bronze Age hoards are far from common finds in Derbyshire and Nottinghamshire. At the time of writing, only one has been recorded on the PAS database from Derbyshire and only two from Nottinghamshire. At just eighteen pieces, the Tuxford Hoard is perhaps less impressive than Bronze Age hoards from other parts of the country. However, the hoard contains a good variety of objects: two leaf-shaped swords, represented by five blade fragments; four socketed axes; a socketed leaf-shaped spearhead; a spearhead fragment; a tanged chisel; a clasp or belt fitting; an unidentified fragment; and four fragments of ingots. All are made of copper-alloy. Four of the sword fragments fit together, forming an

S-shaped blade. This demonstrates that this sword was intentionally bent in order to snap it into pieces (possibly to ritually kill it), a common practice during this period. The other sword-blade fragment has been modified by hammering the blade to make it blunt. This may have been done to create a new hilt after the old, cast one had broken, or it may have turned the fragment into a different tool. Major research projects are being undertaken to learn more about hoards but hoarding in prehistoric Britain is still shrouded in mystery. Many possible explanations have been put forward, including votive offerings to the gods, storing scrap metal or hiding wealth in times of crisis. It is likely that each of these is true for different hoards, but the presence of ingots in the Tuxford Hoard indicates that this was a scrap hoard, although this does not rule out ritual deposition. The absence of written sources from the time means that only archaeology has the potential to reveal the answers. For this reason, it is vital that finders of intact hoards leave them *in situ* for archaeologists to excavate, so that we can learn more about how and why they were deposited.

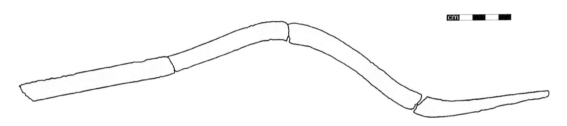

Four of the blade pieces fit together and show how the sword was bent and broken before being deposited.

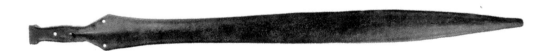

Replica of a Ewart Park type of Bronze Age sword. (Derby Museums Trust)

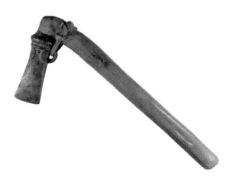

Replica of a hafted socketed axe head. (Derby Museums Trust)

# The Iron Age
# (around 800 BC–AD 43)

The Mid to Late Bronze Age and the Iron Age, like the Neolithic and Early Bronze Age, are often grouped together by academics. This is because there is not a significant moment of change in the landscape, but rather a gradual development from open to enclosed settlements. However, the working of iron has an impact on artefacts. Iron tends to corrode very badly in all but a few conditions, so the metal objects that tend to survive are made of copper-alloy rather than iron. Because iron was now being used to make tools, copper-alloy objects from this period are normally decorative rather than practical in function.

Much of what we know about the people who inhabited Britain during the Iron Age comes from later Roman sources, including Claudius Ptolemy's *Geography* from the second century AD. The Ancient Britons kept no written records themselves and the only inscriptions from the time are the names of rulers on coins. Ptolemy reveals that the name of the tribal group that lived in the East Midlands was the Corieltavi (also known as Corieltauvi, and sometimes mistakenly referred to as the Coritani). During the Roman period, the Corieltavi capital was Ratae Corieltauvorum, modern-day Leicester. The Corieltavi appear to have inhabited the whole of Leicestershire, most of Lincolnshire, Nottinghamshire and Northamptonshire, as well as the southern half of Derbyshire. The hilly north of Derbyshire seems to have been occupied by the Brigantes tribe, whose territories extended northwards along the Pennines.

Iron Age swords and daggers are rare finds in Britain. Here we have a copper-alloy and iron fragment, consisting of the V-shaped lower part of the hilt (the part nearest the blade), which is similar to the cross guard or quillons of a more recent sword or dagger. The decoration of the object is in a three-dimensional style of Celtic art more common in continental Europe, known as 'plastic style'. While it appears to be related to British 'anthropomorphic' hilts seen on a few examples at the British Museum, it is very different from any known examples from Britain, and instead appears much more similar to a sword from France. It therefore seems likely that this was made on the Continent and brought over to Britain, perhaps as a result of trade or elite gift exchange.

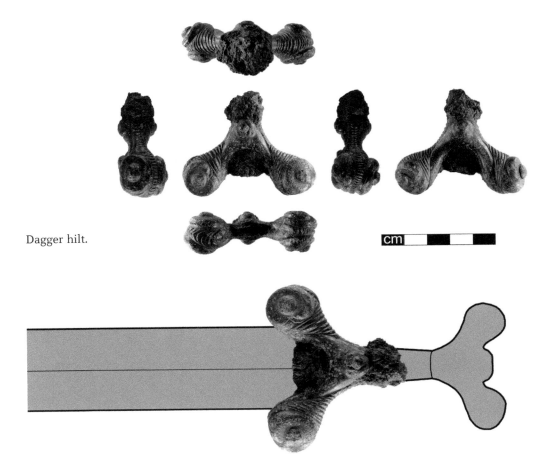

Dagger hilt.

Illustration showing how this dagger hilt would have been fitted to a dagger. (Illustration by Alastair Willis)

**12. Pillar stone (DENO-B69D3A)**
Middle to Late Iron Age (around 300–1 BC).
Discovered between 2005 and 2007 in the River Derwent, near Duffield, Derbyshire.

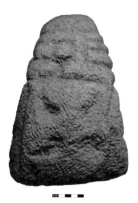 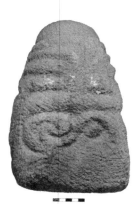

*Left*: Four leaf-shaped carvings on the pillar stone, which are very similar to one side of the Kermaria Stone.

*Right*: S-shaped carvings on the pillar stone.

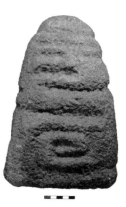 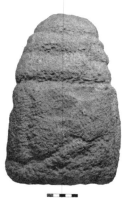

*Left*: Spiral carving on the pillar stone.

*Right*: The carvings on this side are too worn to decipher.

The carvings on this stone are very similar to those on the Kermaria Stone, an Iron Age pillar stone from the Finistère region of western Brittany in France. The Kermaria Stone is one of several hundred ritual stones of various shapes and sizes – found in the Rhineland, Finistère and Ireland – which sometimes have carved decoration on them. Its function is unknown. The decoration on the pillar stone from the Derwent is so similar to that on the Kermaria Stone that it is likely the different craftsmen based the decoration on a particular set of art.

**13. Horn cap (DENO-4D7D2F)**
Middle to Late Iron Age (around 300 BC–AD 43).
Discovered in 2015 in Wormhill, Derbyshire.
Buxton Museum and Art Gallery.

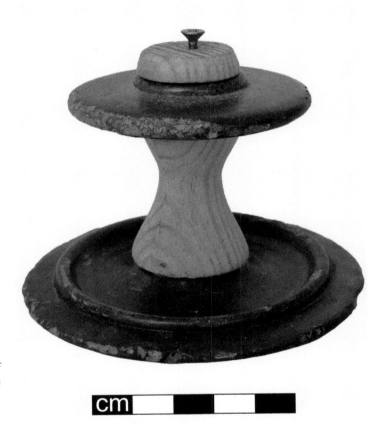

The horn cap with a wooden reconstruction of the shaft that would have joined the two pieces together, provided by the finder.

Mystery surrounds the purpose of these copper-alloy objects. A Victorian theory that they were fixed to the ends of chariots' axles has been dismissed, because the axles of excavated chariots are too large to fit in the holes on the base of horn caps. Some archaeologists still think that horn caps are chariot fittings, perhaps handles or decorative yoke terminals, but problematically none has been found with a chariot. Alternatively, they could be the tops of ceremonial staffs.

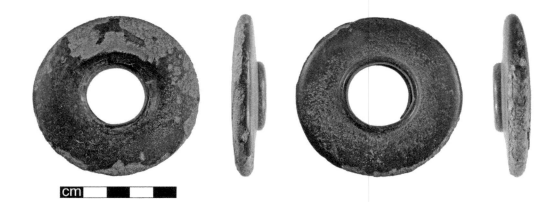

The upper part of the horn cap.

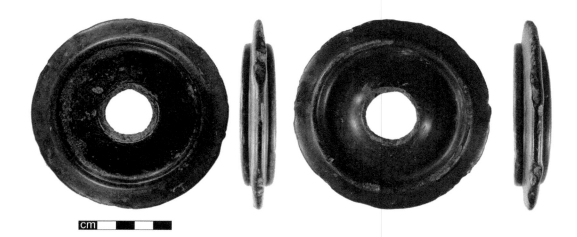

The lower part of the horn cap.

**14. The 'Newark Torc' (DENO-4B33B7)**
Middle to Late Iron Age (around 250–50 BC).
Discovered in 2005 near Newark, Nottinghamshire.
National Civil War Centre – Newark Museum.

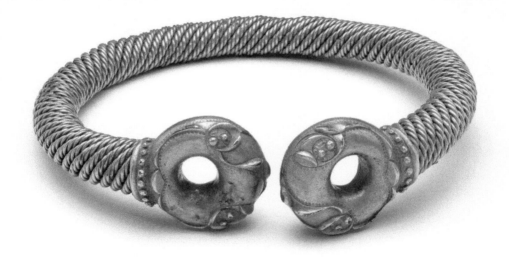

*Above and right*:
The Newark Torc.

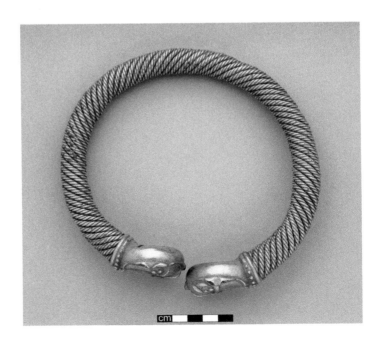

This beautiful object provides an insight into the wealth of a few elite individuals in pre-Roman Britain. A torc was a neck ornament worn by people of status in Ancient British society. This particular one is made from electrum, an alloy of gold and silver. It is formed from eight ropes of four strands each, with large donut-like terminals decorated in the *La Tène* style. Gold torcs are rare finds, especially outside of East Anglia (this is the first and currently only one to have been found in Nottinghamshire). Interestingly, the Newark Torc is so similar to the Sedgeford Torc from Norfolk that they were almost certainly made by the same craftsman.

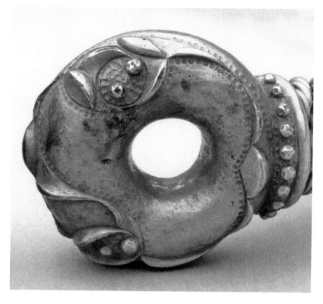

Close-up of one of the donut-shaped terminals on the Newark Torc.

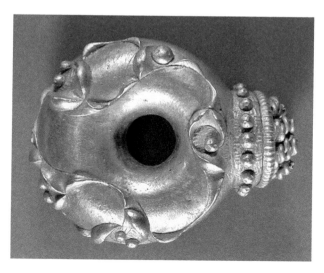

A terminal of the Sedgeford Torc, discovered in Norfolk (PAS-Fo7oD5).

**15. Gold 'Lindsey scyphate' quarter stater (DENO-D9B7E3)**
Late Iron Age (around 60–30 BC).
Discovered in 2015 near Belper, Derbyshire.

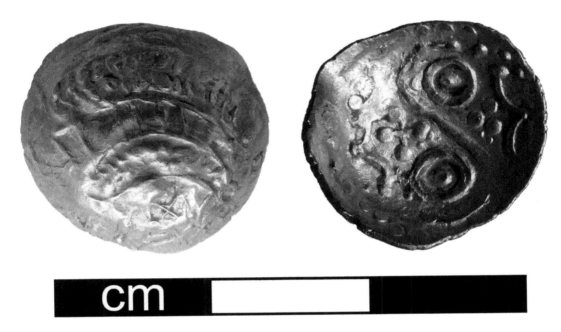

'Lindsey scyphate' stater.

This type of coin is known as a scyphate stater, so called because of its dish-shaped appearance (*skyphos* in Greek means cup). They are normally found in Lincolnshire, an area traditionally associated with the Corieltavi tribe. Derbyshire never produced any coins itself in the Iron Age so pre-Roman coins are unusual finds here (so far, only eleven single finds and one small coin hoard have been recorded on the PAS database). This is the second-most westerly recorded scyphate stater. Other coins of the Corieltavi have been found as far away as Wales and Dorset, although they are mostly concentrated in the East Midlands.

Illustration showing why this type of coin is known as a 'scyphate' stater. (Illustration by Alastair Willis)

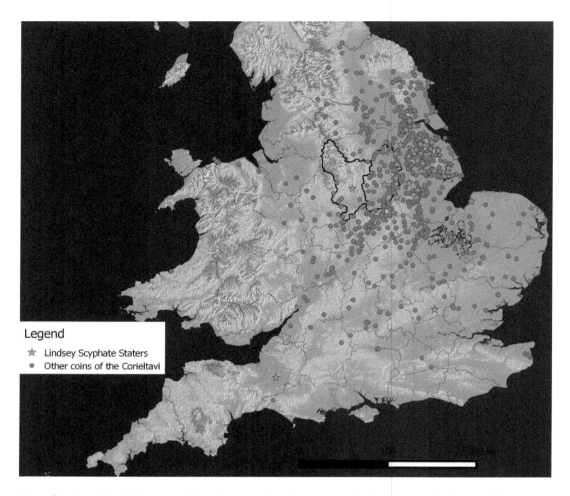

Map showing the findspots of 'Lyndsey scyphate' staters and other coins of the Corieltavi. (Contains OS data © Crown copyright and database right (2016))

## 16. Stone head (DENO-B52638)
Possibly Later Iron Age or Romano-British (around 100 BC–AD *c.* 100).
Discovered in 2012/3 in Ashbourne, Derbyshire.

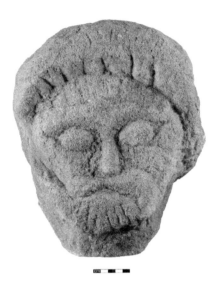 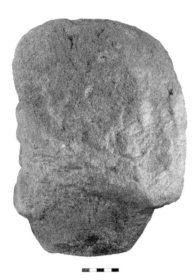

Stone head (front and side views)

Stone heads are notoriously difficult to date. We know from excavated examples that stone heads were made by Ancient Britons during the Iron Age, but they were also produced in many periods since. This particular head shares many characteristics with known Iron Age stone heads, including a flat face, expressionless, lentoid eyes and a simple, flat, triangular nose. The carving also lacks the realism of many later stone heads. However, the possibility cannot be excluded that this head was created in the seventeenth century or later. Without a datable context, it is impossible to know for certain. Stone heads of this later period are enigmatic finds, usually associated with the Pennines (including the north of Derbyshire).

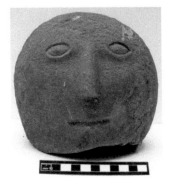

A comparable stone head attributed to the seventeenth century from High Peak, Derbyshire (DENO-7EC2D5).

# The Roman Period (AD 43–402)

Unlike many of the surrounding counties, Nottinghamshire has very few Roman sites that survive in good condition. The town of Margidunum is one of the few exceptions. Additionally, the Fosse Way – the Roman road that crosses the county from Lincoln to Exeter – is still used to this day, although now as the A46. By contrast, there is a number of Roman forts and settlements in Derbyshire that are still visible or well known today. These include Derventio (Little Chester, Derby), Melandra (Glossop) and other excavated forts. There are also potential settlement sites, which have yet to be excavated, which are likely to have survived in good condition. The main reason for this difference in survival is probably that most of the Nottinghamshire countryside is arable, whereas much of Derbyshire is pastoral. Standing buildings and earthworks in Nottinghamshire are likely

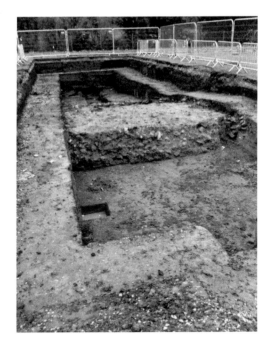

Excavations in 2016 reveal the ramparts of the Roman fort at Little Chester, Derby. (Trent & Peak Archaeology)

to have been flattened by farmers, and their stone robbed for use in other buildings, especially in the couple of centuries before the 1882 Ancient Monuments Protection Act. Much of the evidence for settlements in Nottinghamshire comes from crop marks and artefact scatters, which is why the PAS database is so vital for understanding Roman archaeology. Despite the lack of visible sites in Nottinghamshire, more than 5,000 Roman finds (excluding hoards) from the county have been recorded on the PAS database, compared to just over 600 in Derbyshire. The most common Roman finds are copper-alloy coins and brooches.

Soon after their invasion of Britain in AD 43, the Romans had conquered the whole of the south-eastern part of Britain. Neither the Corieltavi nor the area they inhabited are mentioned by the ancient sources recording the conquest. Therefore, it is assumed that there was no significant resistance to Roman rule in the East Midlands. It is possible that the area became an independent client kingdom, which was later absorbed into the Roman Empire. The Corieltavi capital, Ratae, at Leicester became an important Roman town in the region. However, the large number of forts and marching camps in Derbyshire and Nottinghamshire could suggest that the Romans maintained a watchful military presence.

For the first thirty years of Roman occupation, the River Trent acted as a natural boundary between the conquered south-east and the untamed north-west. This frontier was fortified during the AD 50s and 70s with a series of forts in the area to the north-west of the Trent. For the most part these forts were abandoned soon afterwards as the Roman army advanced into north-west England, but some sites such as Little Chester continued to be used into the third century.

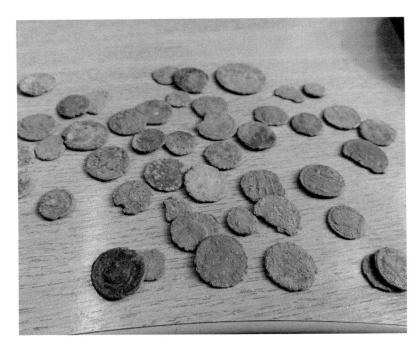

Roman third- and fourth-century coins are by far the most common finds discovered by metal detectorists in the south and east of England.

**17. Legionary** *patera* **(DENO-8E0669)**
Early Roman (around AD 43–200).
Discovered in 2015 near Ollerton, Nottinghamshire.
National Civil War Centre – Newark Museum.

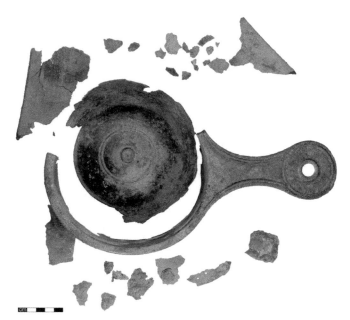

Legionary cooking pot or
*patera*.

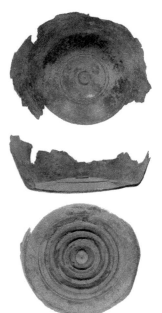

The base of the *patera* was designed to spread heat quickly.

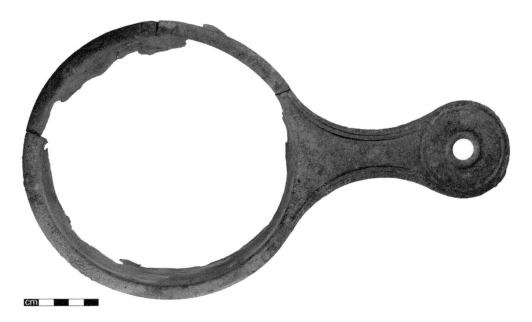

The rim and handle of the *patera* fitted back together.

Most cooking during the Roman period would have been done in pottery vessels, but such objects were heavy and easily broken, and not suitable for soldiers on the move. Therefore, copper-alloy cooking pans like this were a standard part of a legionary's marching equipment. They are easily recognisable by the moulded concentric rings in their base – designed to spread heat quickly and evenly – and their handle, with its disc-shaped terminal and round suspension hole. More than sixty of these objects have been recorded across the country, but most are represented by small handle fragments. It is rare to find one that is as complete – albeit in a fragmented state – as this one.

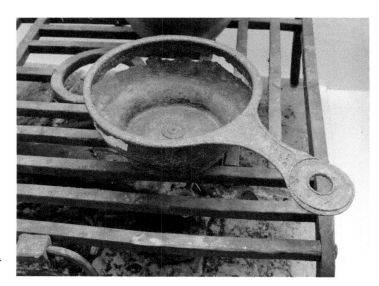

A similar Roman *patera*, discovered at Attenborough gravel pits. (Derby Museums Trust)

## 18. Slingshots (PUBLIC-640928)
Roman (around AD 43–402).
Discovered in 2014 in Catton, Derbyshire.

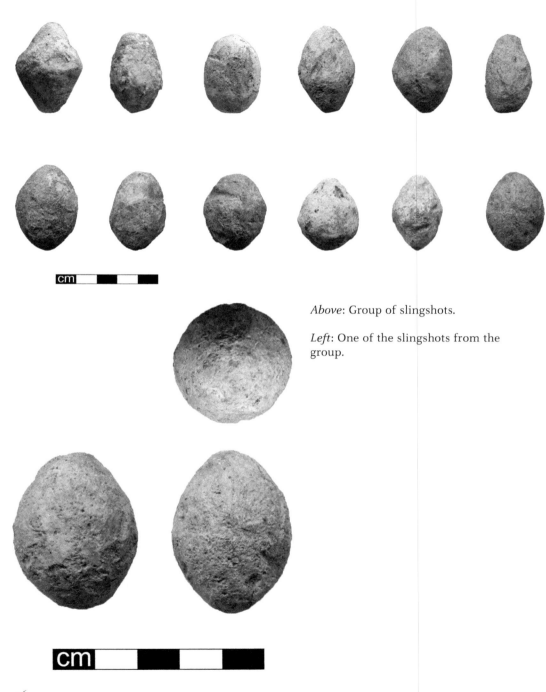

*Above*: Group of slingshots.

*Left*: One of the slingshots from the group.

Lead slingshots are often overlooked or mistaken for lead weights. The finder of these slingshots plotted them individually using GPS and, as a result, we can map these accurately to give us a scatter that can be used in research. This particular group has provoked interest from archaeologists who have found similar slingshots while excavating at Burnswark Hill Fort, Dumfries. The scatter suggests that a slinger or slingers were either practicing here or firing at a live target. The Romans employed slingers as auxiliaries within their armies; they were originally recruited exclusively from the Balearic Islands but, by this time, were recruited from different sources. The Ancient Britons also used slings.

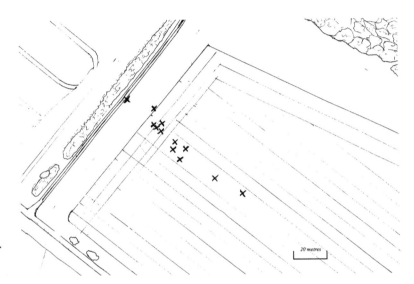

Map showing the scatter of this group of slingshots. (Illustration by Alastair Willis)

20 metres

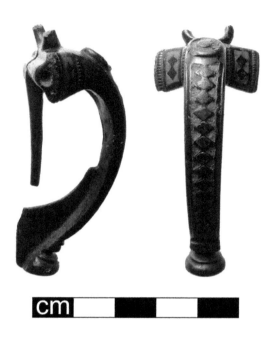

Headstud brooch inlaid with red enamel.

Roman jewellery was often embellished with coloured enamel, a powdered form of glass, but most of the time the enamel does not stand the test of time and is either very worn or completely missing. Here, however, we have a copper-alloy brooch with all its enamel intact, the colour as vivid as it would have been nearly 2,000 years ago. Finds like this really help the viewer to connect with the past and to appreciate how colourful ancient jewellery was.

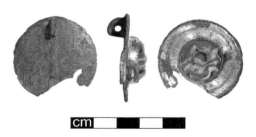

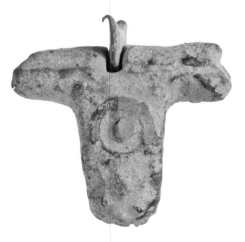

*Above*: A disc brooch from Clipstone, Nottinghamshire, inlaid with coloured glass and gilded around its edge.

*Right*: Roman brooches are more often found in a worn and fragmented state like this one from Rampton, Nottinghamshire (NLM-834F9F).

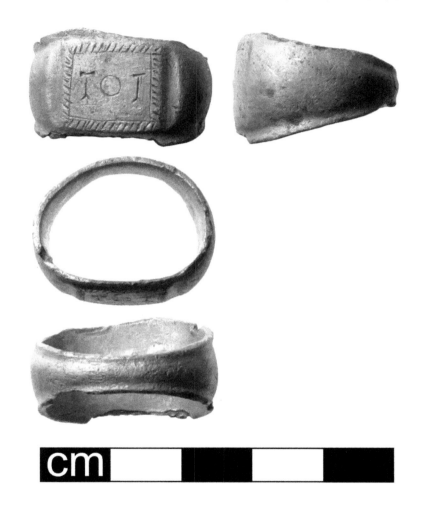

ToT ring.

Religion was a hugely important part of life for people in the ancient world. The Romans appreciated this and sought to link their own gods with those of the people they conquered, so as to avoid potential unrest. This process, known as syncretism, resulted in gods such as Sulis Minerva, who was worshipped at Bath. Syncretism also occurred to link Mars, the Roman god of war, with Toutatis, an important Celtic god (also associated with war). Toutatis remained a popular god in the East Midlands long after the Roman conquest of Britain, and this is most visible on ToT rings from the East Midlands. ToT rings are typically found in Lincolnshire, but are also found across other parts of the area traditionally associated with the Corieltavi. These rings probably reflect a traditional local worship that, by the second century AD, had manifested itself in inscribed rings.

**21. Drachm from the Saurashtra Peninsula in western India (DENO-1080E2)**
Early Roman (around AD 119–124).
Discovered in 1998 near Kings Clipstone, Nottinghamshire.

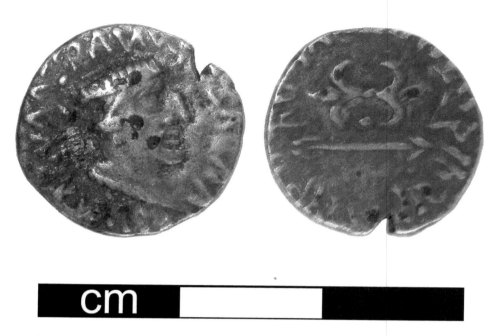

Drachm of King Nahapana.

Coins sometimes travelled very long distances. It is not unusual for Roman coins struck in mints in the Eastern Mediterranean to be found in Britain, especially if they were types that were used across the Empire. However, it is very rare for coins of other contemporary cultures to appear as finds in this country. This coin is a silver drachm of King Nahapana, a Kshaharata (Western Satrap) ruler who reigned around AD 105–125. The Kshaharata dynasty was based in the Saurashtra Peninsula in western India and had trade links with Rome and the other empires in the Middle East. The design on the drachm imitates drachms that continued to be used in the Greek cities in the Eastern Mediterranean; its inscription is even in Greek. The Saurashtra Peninsula is just beyond the furthest extent of Alexander the Great's empire, so it seems likely that the adoption of this style of coinage was a result of exposure to the Greek coinage of Alexander's successors. Exotic coins like this are occasionally found in Britain; and many of them appear to be recent losses, i.e. brought to this country by collectors as souvenirs over the last two or three centuries. However, unlike modern coins, ancient coins contained precious metal and thus had intrinsic value. The drachm's size and weight is similar to the silver denarii that were being used in across most of the Roman Empire, so it is possible that this ended up in Nottinghamshire as a result of changing hands multiple times through trade.

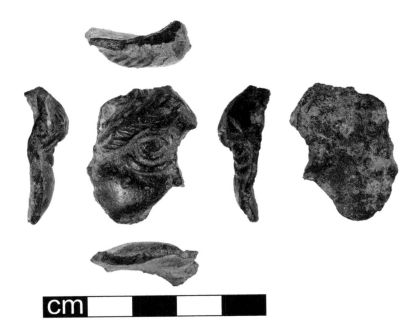

Statue fragment.

Roman bronze statue fragments are rare finds, although slightly more common in the East Midlands than in other parts of the country. Bronze is a recyclable material, and statues were often broken up and melted down for reuse. This fragment survived at least part of the process. Based on the features depicted on the fragment, the complete statue would have stood at just over a foot in height. The statue is perhaps most likely to have represented one of the Roman emperors or a god.

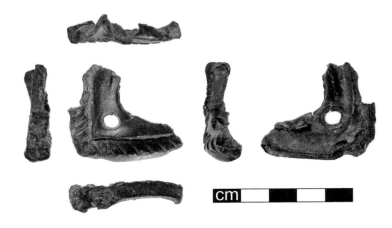

This object was found beside the statue fragment and may be part of its base.

**23. The 'Amber Valley Hoard' (DENO-A6AE06)**
Late Roman (around AD 275–285).
Discovered in 2010 in Ripley, Derbyshire.
Derby Museum and Art Gallery.

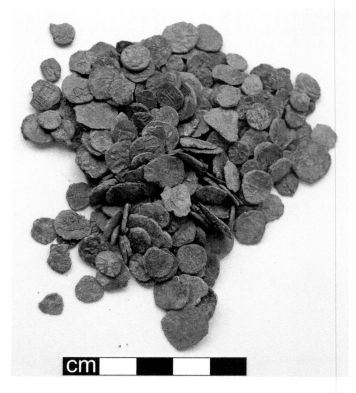

Some of the coins from the Amber Valley Hoard.

Contemporary copies, i.e. unofficial ancient forgeries of official Roman coins, are very common finds from the late third and fourth centuries AD. They range in quality from near identical copies to very crude or abstract imitations of official coins that could never be mistaken for the real thing. The reason such coins are so common in this period appears to be a lack of official currency being produced, rather than an attempt to defraud. They are especially common from the period AD 275–285, just following the collapse of the 'Gallic Empire', when the mints in Gaul ceased production of coins for the local population and the mints in Rome were not yet producing enough coins to cover the shortfall. The Amber Valley Hoard comprised of 3,631 radiates (named after the spiked radiate crown worn by the emperors on the coins), of which only four were officially produced and were issued by the Gallic emperors (Postumus, Victorinus and Tetricus I) between AD 260 and 274. The rest of the coins are copies, referred to as 'barbarous radiates'. Excavations on the site of the find have uncovered Roman buildings, thought to be a Roman villa, dating from the third to the fourth century.

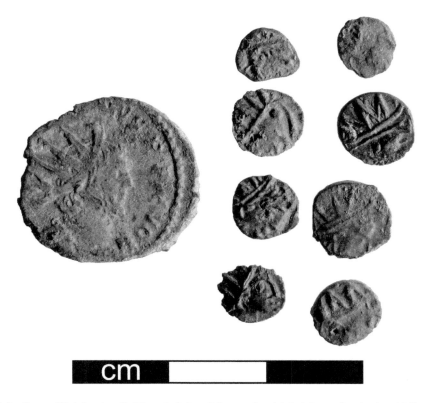

One of the four official coins (left) and eight of the copies (right) from the Amber Valley Hoard.

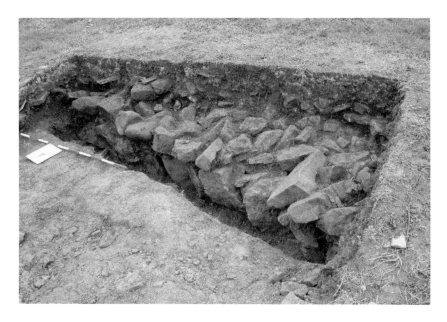

Initial excavations of the Amber Valley hoard led to the discovery of a Roman building. (© Rachel Atherton)

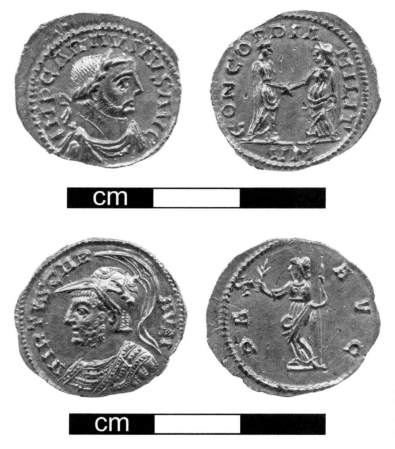

A gold *aureus* of Carausius from the Ashbourne Hoard, minted in Rouen, France.

A gold *aureus* of Carausius from the Ashbourne Hoard, minted in London.

These are two gold *aurei* of Carausius (AD 286–293). Carausius was a Roman general with authority over the Roman northern fleet, based in and around the English Channel. This fleet enabled him to break away and form his own empire in northern Gaul and Britain, which we now know as the 'Britannic Empire'. The bust on one of the coins is quite crude and bears little resemblance to Carausius, instead looking like Maximian (ruler of the Western Roman Empire). This suggests it was hastily struck, early on during Carausius' reign, probably at Rouen where he was proclaimed emperor. The coin with the helmeted bust was minted in London and, at the time of writing, is unique. Gold coins of Carausius are extremely rare, whereas silver ones are much more common. This suggests that gold supplies to Britain were restricted during his reign.

**25. Copy of a gold *solidus* of Constantius II (SWYOR-2B092E)**
Late Roman (AD 347–348).
Discovered in 2015 in Misterton, Nottinghamshire.

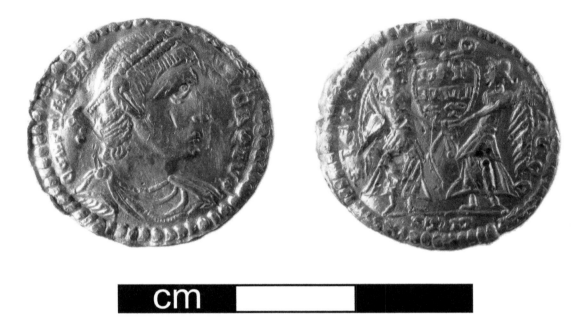

cm

A gold contemporary forgery of a *solidus* of Constantius II.

This is a contemporary copy of a gold *solidus* of Constantius II (AD 323–361). Gold *solidi*, like earlier *aurei*, are very rare finds outside of hoards, for the simple reason that their value was such that someone who lost one would spend a long time searching for it. A significant number of the *solidi* on the PAS database are copies, and we know from Roman writers that gold coins were being increasingly counterfeited in the mid-fourth century, even by the officials in charge of minting them. The major coinage reforms of Valentinian I and Valens in the late 360s were a direct attempt to combat this. Unlike many other copies of gold coins, this coin is actually completely made of gold rather than gold-plated. The details that give the true identity of this coin away are the lack of uniformity in the size of the letters, and the crudely realised depiction of Constantius' portrait and of the Victories on the reverse.

**26. Valentinianic** *nummi* **(e.g. DENO-3328D9)**
Late Roman (AD 364–378).
Discovered in 2015 near Cotham, Nottinghamshire.

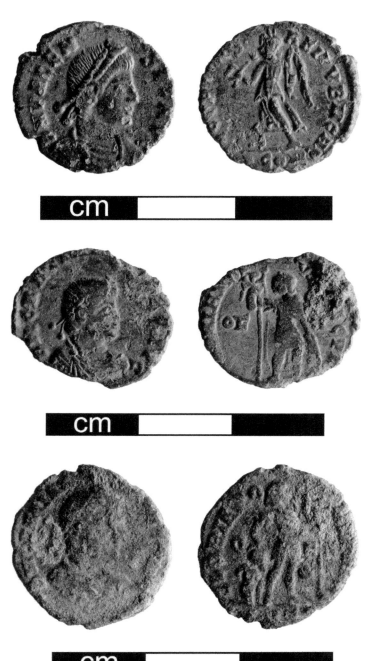

*Nummus* of Valens, minted in Arles. The reverse shows Victory holding a wreath and palm and says, '*SECVRITAS REI PVBLICAE*' (DENO-3328D9).

*Nummus* of Gratian, minted it Arles. The reverse shows Gratian holding a standard and says, '*GLORIA NOVI SAECVLI*' (DENO-3402B1).

*Nummus* of Gratian, minted in Lyon. The reverse shows the Emperor dragging a captive and says, '*GLORIA ROMANORVM*' (DENO-34B7F5).

While unremarkable on their own, these copper-alloy coins are often found by metal detectorists in Nottinghamshire. The area was, and continues to be, good for farming, and it appears to have been exploited heavily during the second half of the fourth century in order to feed the Roman armies along the Rhine frontier. Ancient sources tell us that, during the reign of Julian (AD 355–363), the number of ships in the North Sea fleet was tripled and new granaries were built to accommodate grain being shipped from Britain. As a result of the increased level of farming, more coins were supplied to Nottinghamshire in order to pay suppliers, and therefore more coins were dropped and lost. A similar situation can be seen in Wiltshire, Lincolnshire and East Anglia.

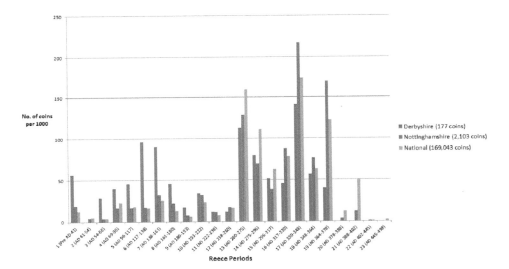

Reece Period analysis showing the relative number of coins from each period in Derbyshire, Nottinghamshire and nationally. We can see that Nottinghamshire has a significantly above average peak in Reece Period 19 (AD 364–378). Data accurate as of January 2016.

# The Early Medieval Period (AD 402–1066)

With the collapse of the Roman Empire in the West, England fell prey to invading Angles and Saxons. Eventually the country was split between rival kingdoms. Both Derbyshire and Nottinghamshire became part of the Kingdom of Mercia. Much of the Anglo-Saxon period is still shrouded in mystery, but the discoveries of the ship burial at Sutton Hoo in 1939 and the Staffordshire Hoard in 2009 shed light on the period traditionally referred to as the Dark Ages. They revealed the extreme wealth of the elite in Anglo-Saxon society and the superb craftsmanship that existed in England between the sixth and eighth centuries. However, outside of these large assemblages of riches, Anglo-Saxon and Viking material culture is relatively scarce. The Viking Great Army's winter camp at Repton in Derbyshire is one of the few known Viking sites in the region. Early medieval finds are relatively uncommon, making up about 4 per cent of the records on the PAS database, both nationally and in Derbyshire and Nottinghamshire.

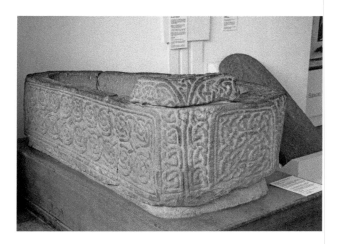

St Alkmund's sarcophagus, dating to around AD 800, is decorated with a carved interlace pattern, typical of Anglo-Saxon art from the period. The sarcophagus was discovered when St Alkmund's Church in Derby was demolished in 1968. (Derby Museums Trust)

**27. Lunate pendant (DENO-E601A3)**
Early Medieval (around AD 500–650).
Discovered in 2015 near Kelham Hills, Nottinghamshire.
National Civil War Centre – Newark Museum.

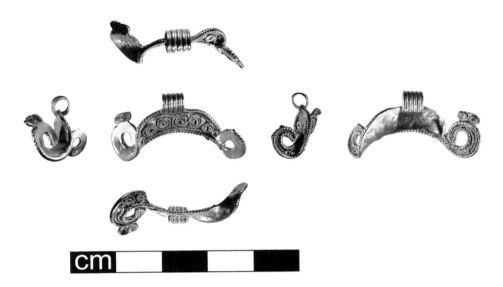

Lunate pendant.

The Anglo-Saxons were experts at working with gold. This gold lunate pendant is intricately decorated with gold filigree – tiny gold beaded wire – soldered to the surface of the pendant. The filigree is arranged in a series of figure-of-eight spirals, with a double border of thin and thick filigree wires. The pendant was originally a flat crescent, its design derived from a common motif of two confronted birds' heads.

*Left*: Illustration of how the shape of the pendant would have originally looked. (Illustration by Alastair Willis)

*Right*: A buckle from Norfolk, decorated with the confronted birds motif (NMS-816A96).

**28. Cross-shaped pendant (DENO-89E427)**
Early Medieval (around AD 500–700).
Discovered in 2007 near Newark, Nottinghamshire.
National Civil War Centre – Newark Museum.

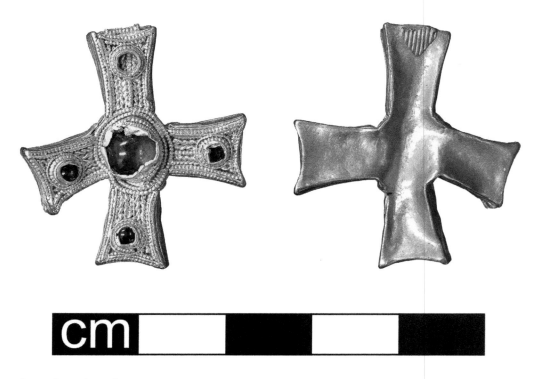

cm

Cross-shaped pendant.

The gold-work on this cross is incredibly intricate, with multiple strands of gold filigree wire covering most of its surface. The Anglo-Saxons are also known for their use of garnets, and their skill at decorating objects with them can be seen in the next object. However, this cross is rather unusual, as the gems set into it have been very crudely inlaid. At the end of each arm of the cross is a setting for a garnet. Two of them contain cabochon (polished, not facetted) garnets. Another is flat and unpolished and the fourth is missing. There is also a large cabochon gem at the centre. The settings for each of the garnets appear to have been roughly squeezed around the garnets, as if the stones were the wrong size for the settings. The use of an unpolished flat garnet is also very odd. It therefore seems likely that either the garnets are replacements for the lost originals or that the craftsman did not have access to gems of the right size. Garnets are found across Europe but most are not 'gem-quality'. The Anglo-Saxons used garnets sourced from Bohemia, India and Sri Lanka. These precious stones would have been acquired by the Saxons through trade and then may have been worked and polished at central workshops outside of Britain. It is entirely likely that these precious stones were brought up major rivers like the Trent.

**29. Sword button (DENO-2A0601)**
Early Medieval (around AD 600–650).
Discovered in 2010 near Cotgrave, Nottinghamshire.
Ashmolean Museum.

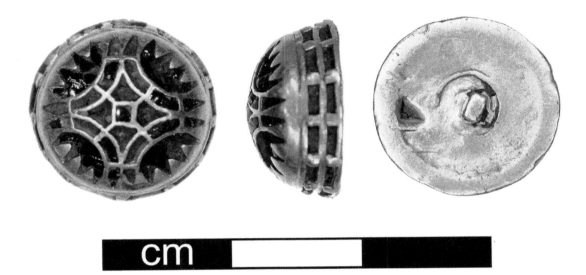

Sword button.

Sword buttons, also known as scabbard bosses, were decorative scabbard fittings. It is debatable as to whether they had a functional or decorative purpose. Sword buttons have been found in both the Sutton Hoo ship burial and the Staffordshire Hoard. This example is one of the most beautiful and complex examples to have been recorded on the PAS database. Its intricate design is closer to those found at Sutton Hoo than those from the Staffordshire hoard. The object is made of gold and is covered with a symmetrical pattern of tiny cells. Each of its cells would have held a garnet with a hatched gold-foil backing. Most of the garnets are missing, but the gold foil is mostly intact.

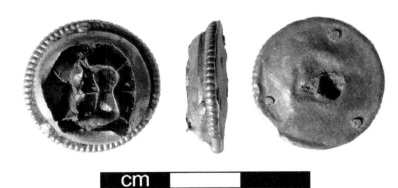

A less intricate and more worn sword button from Norfolk (NMS-274C44).

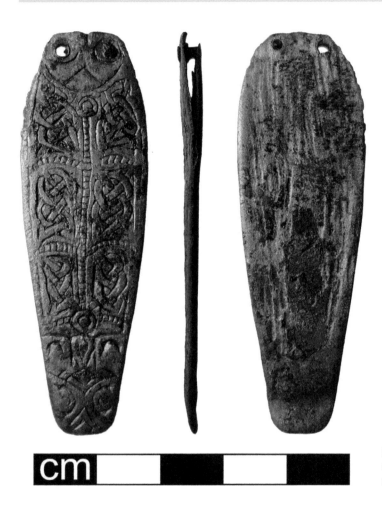

cm

Strap end. (Nottingham
City Museums and
Galleries)

Strap-ends are among the most common artefacts from the early medieval period, with
more than 3,000 recorded on the PAS database. However, only about 100 of them are silver;
almost all the rest are made of copper alloy. This silver example is decorated in a typical
Anglo-Saxon style. At its narrow end is a zoomorphic terminal depicting an animal mask,
while the rest of the strap end is decorated with six panels of interlace.

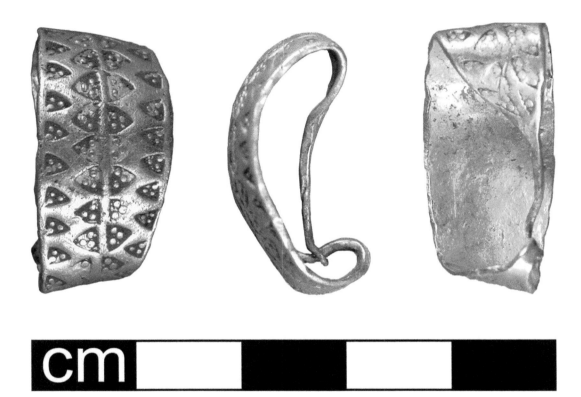

**31. Viking finger ring (DENO-9A6C17)**
Early Medieval (around AD 850–1000).
Discovered in 2007 near Newark, Nottinghamshire.
The British Museum.

cm

Viking ring.

Objects we can specifically attribute to the Vikings are uncommon in Derbyshire and Nottinghamshire. The form and decoration of this gold ring are typical of Viking jewellery. The punched decoration, consisting of lines of triangles containing three pellets, is very similar to that on rings found at Thetford in Norfolk, in Warwickshire and at Repton Derbyshire.

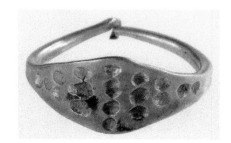

A comparable Viking ring from Repton, Derbyshire.
(Derby Museums Trust)

**32. Cut halfpenny of Edward the Confessor (LEIC-AF78C2)**
Early Medieval (AD 1053–1056).
Discovered in 2012 near Hickling, Nottinghamshire.

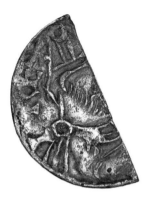

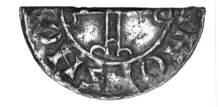

Cut halfpenny
of Edward
the Confessor,
minted in
Nottingham.

Both Nottingham and Derby had their own mints in the tenth to early twelfth centuries, but so far only four coins have been recorded on the PAS database from the Nottingham mint and only one from the Derby mint. This example, a silver halfpenny of Edward the Confessor (AD 1042–1066), minted at Nottingham, is the only one of these to have been found in Nottinghamshire. Until the reign of Edward I (AD 1272–1307), the penny was the only minted coin; there were no smaller denominations. Therefore, to make smaller denominations to use as small change, pennies would be cut in half to make a halfpenny and into quarters to make farthings. There were seventy-three different mints active during the reign of Edward the Confessor and as many as eighty-seven under his predecessors. The site of the main Nottingham mint has yet to be discovered, but it is likely to be somewhere in the centre of the city.

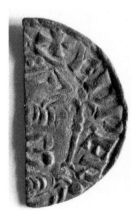

A different cut halfpenny of Edward the Confessor from Norfolk, showing how the other half of the obverse would have looked. (NMS-8C5CC4)

# The Medieval Period
# (AD 1066–1540)

Following the Norman Conquest, England's new rulers were quick to strengthen their hold on the country. The Normans and the Plantagenets built many castles across England; Derbyshire and Nottinghamshire were no exceptions. Nottingham Castle and Newark Castle are the most well-known, but there are many other castles and fortified sites in both counties, although many of these have disappeared from sight. One of the most significant sites is 'King John's Palace' at Kings Clipstone, a royal residence visited by English kings between Henry II and Richard II (AD 1154–1399). Silver coins and copper-alloy buckles are the most common finds from this period. Derbyshire is unusual for having more medieval finds recorded on the PAS database than Roman.

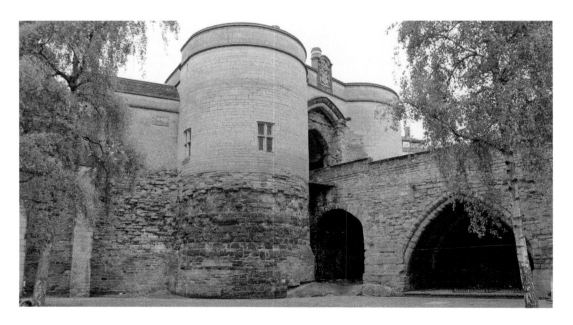

Victorian renovation of Nottingham Castle's gatehouse, with the original medieval stonework visible below.

The seventeenth-century ducal palace, built on the site of the medieval castle in Nottingham.

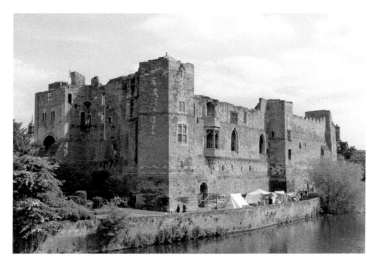

Newark Castle. (© Lucy Young 2016)

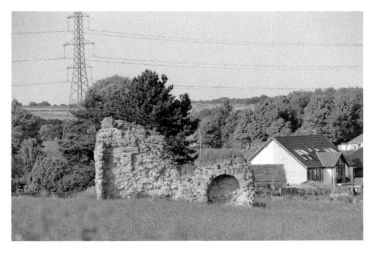

The ruins of 'King John's Palace' at Kings Clipstone. (© Lucy Young 2016)

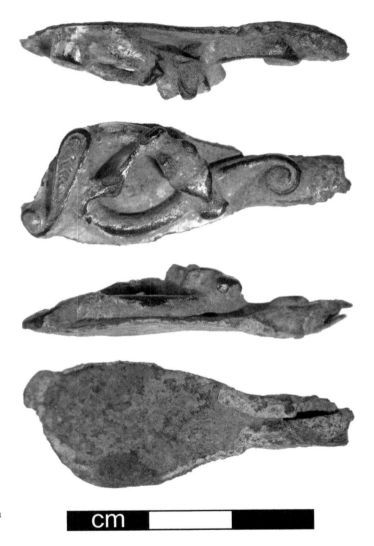

Stylus head, decorated with
a sleeping wyvern.

cm

A wyvern is a mythical creature, similar to a dragon but with two legs instead of four (although sometimes the legs are not depicted). It is a popular heraldic symbol, especially in the East Midlands. It was used as the crest of the Corporation of Leicester's coat of arms from 1619 and on the arms of the Midland Railway in 1845. It has been claimed that the wyvern was a symbol of Mercia, but there is little supporting evidence for this. Here, a sleeping wyvern, curled up rather like a pet dog, decorates what appears to be the copper-alloy head of a stylus or pointer, which could have been ecclesiastical.

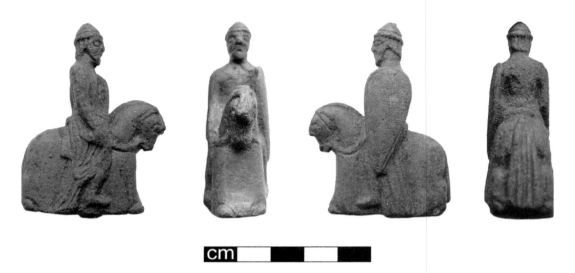

The Carlton-in-Lindrick Knight.

This copper-alloy figurine of an armoured horseman is reminiscent of the knights in the famous Lewis Chessmen. It shows a knight wearing a conical helmet and carrying a long kite shield, which was introduced to England by the Normans and was designed to give protection to both the torso and the leg. The horse wears a caparison, a long cloth that was both decorative and functional, serving to give some protection to the horse but also to display the knight's coat of arms. These three pieces of equipment – the helmet, the kite shield and the caparison – all indicate a date of the late twelfth to the early thirteenth century. The figurine could be a chessman but, unlike most chess pieces from the period, it is made of copper-alloy rather than ivory. Also there are traces of solder on the uneven base of the figurine, revealing that it was probably attached to a separate base or a larger object. If that is the case, then its function is a mystery. However, it is an important find, as three-dimensional depictions of mounted knights from the period are very rare.

## 35. The 'Kirk Ireton Hoard' (YORYM-755D34)
Medieval (AD 1248–1272).
Discovered in 2012 near Ashbourne, Derbyshire.
Buxton Museum and Art Gallery.

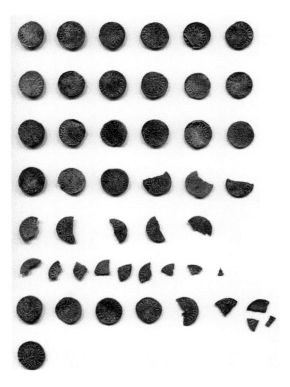

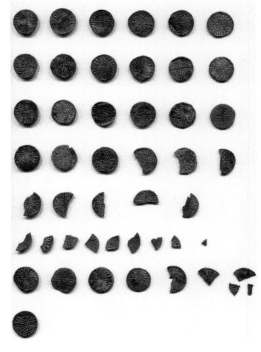

*Above*: Coins of Henry III from the Kirk Ireton Hoard (obverses).

*Right*: Coins of Henry III from the Kirk Ireton Hoard (reverses).

This is the largest of four medieval coin hoards from Derbyshire and recorded by the PAS. It contains forty-three silver pennies issued during the reign of Henry III (AD 1216–1272). Twenty-six of the coins are complete; the rest are in varying states of incompleteness. Cut halfpennies and farthings are more common as single finds than complete pennies, but hoards tend to include only complete pennies. There is no evidence that any of the coins in this hoard were cut. The other medieval coin hoards from Derbyshire date to the reigns of Henry II (AD 1154–1189), Henry III and Edward I to Edward III (AD 1272–1377).

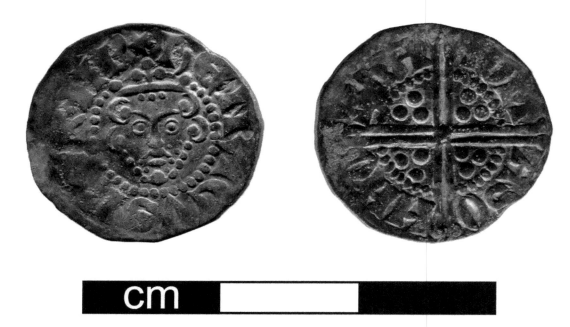

A silver penny from the Kirk Ireton Hoard. The reverse tells us that it was minted in Northampton and that the moneyer, the man in charge of the mint, was called Tomas.

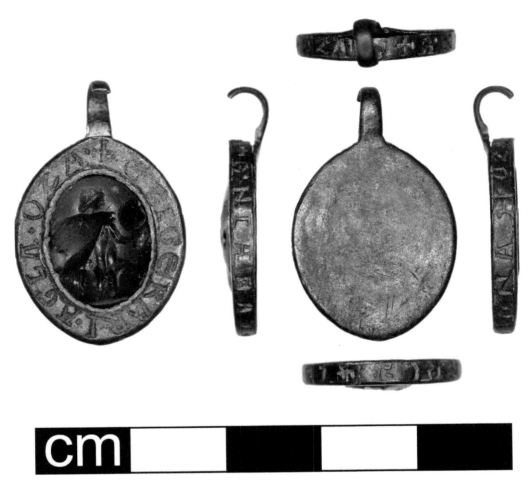

Medieval pendant with a Roman intaglio.

Since the collapse of the Western Roman Empire, the inhabitants and rulers of lands formerly under Roman rule continued to emulate the period by copying Roman art and architecture, but also by reusing Roman artefacts. This silver pendant is inlaid with a Roman carnelian intaglio (engraved gem) depicting 'Bonus Eventus', a personification of good fortune/success. The depiction corresponds nicely with the inscriptions around the edges of the pendant, which are amuletic in nature. Some of the inscriptions are abbreviations of popular charms meant to prevent ailments such as fever and 'falling sickness' – thought to be either epilepsy or even intoxication.

## 37. Finger rings (DENO-508A9A and DENO-5082A6.)
Late Medieval (around AD 1400–1550).
Discovered in 2015 near East Bridgford, Nottinghamshire.

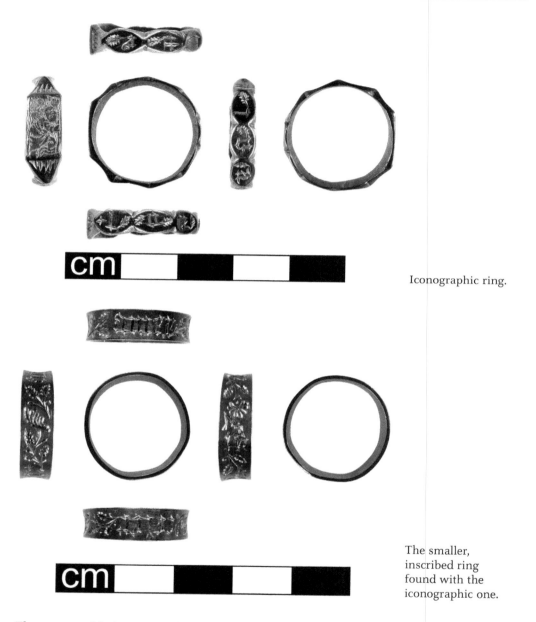

Iconographic ring.

The smaller, inscribed ring found with the iconographic one.

These two gold rings were discovered together, one inside the other. The larger ring is iconographic; its bezel depicts St Christopher carrying Jesus as a child across a swollen river. The hoop of the ring is divided into panels and inscribed '*loyalte*'.

The smaller ring is a simpler, circular band, inscribed in similar letters to the larger ring. The inscription reads 'amen et celer', French for 'love and conceal (that love)', a tenet of courtly love. Why these rings were buried together is a mystery, but one could come up with many different theories. The differing sizes might indicate that they belonged to a man and a woman, lovers perhaps, whose secret relationship ended tragically.

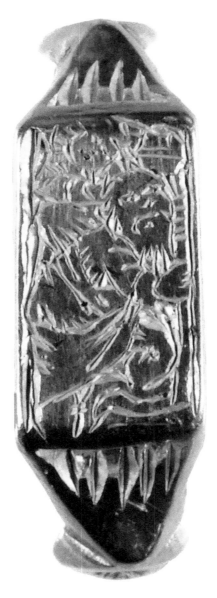

Bezel of the iconographic ring, showing St Christopher carrying Jesus across a river.

**38. Apostle spoon (LVPL-883FF2)**
Late Medieval to Early Post-Medieval (around AD 1500–1600).
Discovered in 2011 near Bawtry, Nottinghamshire.
Bassetlaw Museum.

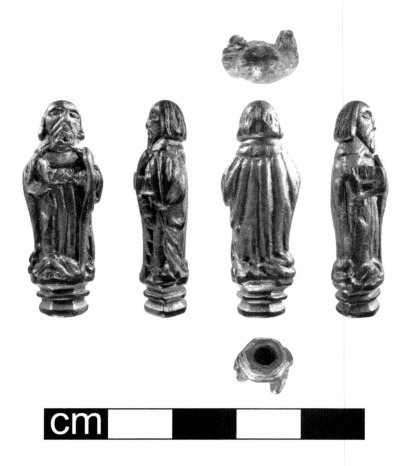

Apostle spoon.

Christianity played a much more significant role in medieval society than it does today. This figurine is the finial of a silver spoon and depicts one of the Twelve Apostles. He appears to be holding a long saw in his left hand, which would indicate that this represents Saint Simon Zealotes ('the Zealot'), who, according to some traditions, was sawn in half by pagan priests in Persia. Apostle spoons were often given as christening gifts, both in sets (including all the Apostles and Christ and/or the Virgin Mary) and as individual spoons, depending on the wealth of the buyer. This one is made of silver, but some others are made of pewter or copper alloy. Details are picked out in gilt.

## 39. The 'Tuxford Crucifix' (DENO-F90404)
Late Medieval to Early Post-Medieval (around AD 1500–1600).
Discovered in 2008 near Tuxford, Nottinghamshire.
Bassetlaw Museum.

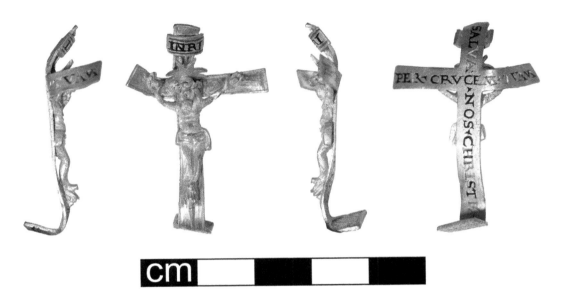

The Tuxford Crucifix.

This sixteenth-century gold crucifix is a masterpiece of Tudor/Elizabethan craftsmanship. The figure of Christ would have originally been covered in white enamel to contrast him with the gold cross. Small areas of this enamel are still present, and the rest of the body is covered in small scratches intended to hold the enamel in place. The figure of Christ is intricately moulded, complete with loincloth, crown of thorns, radiate and tiny nails piercing his hands and feet. The cross is surmounted with a transverse plaque that reads 'Jesus of Nazareth, King of the Jews' in black enamel in INRI. The reverse of the cross also bears an inscription, '*PER CRVCEM TVAM SALVA NOS CHRISTE*', meaning, 'By your cross, save us oh Christ'.

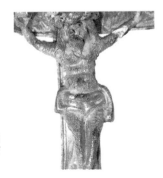

*Left*: The scratches across the surface of Christ's body on the Tuxford crucifix were intended to keep the enamel attached to the surface.

*Right*: A skull engraved at the bottom of the reverse of the crucifix.

# The Post-Medieval Period (AD 1540–1900)

The post-medieval period was an era of significant change for the people and landscape of Derbyshire and Nottinghamshire. It saw two major national events: the English Civil War (really a series of three wars between 1642 and 1651) and the Industrial Revolution. Both counties played a prominent role in these events. Many of the more famous Civil War battles took place in other parts of the country, but the sieges of Newark are well known. Newark remained a Royalist stronghold throughout the First English Civil War, despite three sieges and the rest of the county siding with the Parliamentarians.

In Derbyshire, there was a major expansion in the lead mining industry during the sixteenth and seventeenth centuries. The coal-mining industry was also beginning to grow. In the early eighteenth century, John Lombe built the Silk Mill in Derby, the world's first fully mechanised factory, which sparked the Industrial Revolution. The explosion of new mills and factories in the towns resulted in a massive expansion in urban population. They also greatly increased demand for coal and, as a result, the coal mining industry in Derbyshire and Nottinghamshire thrived. The mills, the lead mines and collieries transformed the landscape more significantly than any previous event since the last glaciation.

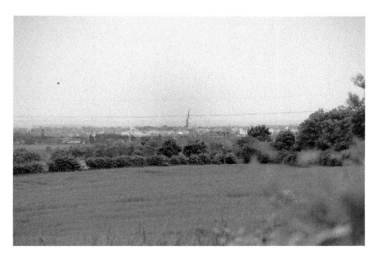

Newark from the hills above South Muskham and Kelham.

A Royalist siege map of Newark's defences dating to 1646. It shows the town in the centre, the King's Sconce (far left) protecting the north-east end of the town and the Queen's Sconce (far right) protecting the south-east end. (National Civil War Centre – Newark Museum, image taken by Doug Jackson)

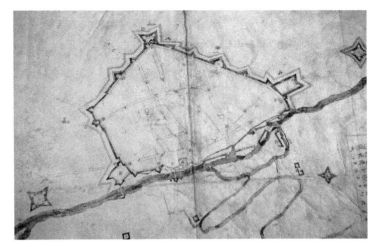

The ramparts of the Queen's Sconce at Newark, part of the town's defences during the Civil War.

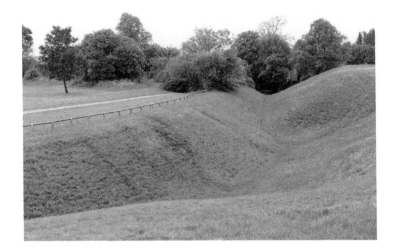

View over the Queen's Sconce.

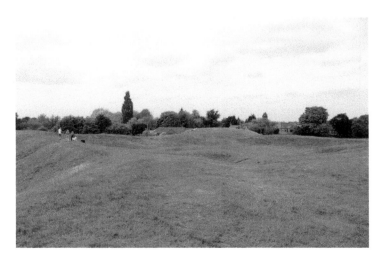

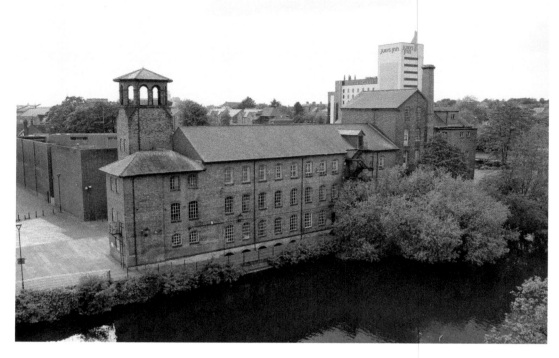

The Silk Mill, Derby.

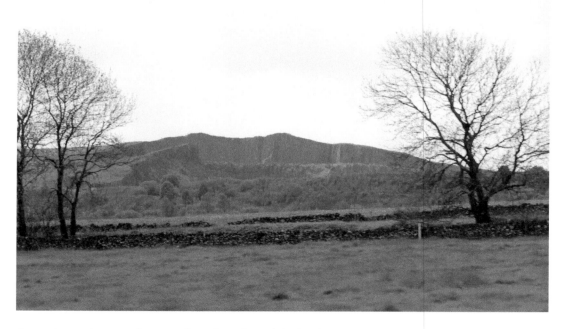

Quarrying and mining has significantly reshaped the landscape of parts of Derbyshire, like here at Hindlow.

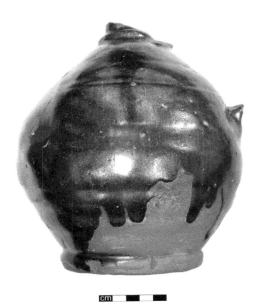

Ticknall ware vessel.

Ticknall in South Derbyshire was the centre of a major pottery industry from the thirteenth century up until the nineteenth century, and many pottery kilns have been found in the area. The pottery was distributed across the Midlands through markets. Most of the vessels it produced were kitchen or dairy wares. This vessel has a metallic purple-brown glaze covering most of its external surface, which was popular in the sixteenth century.

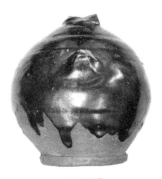

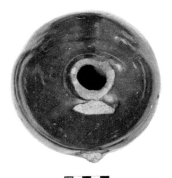

*Left*: The purple-brown glaze on this jug is typical of Ticknall ware.

*Right*: Ticknall vessel (from above).

**41. Toothpick/earscoop pendant (DENO-E6E8D8)**
Post-Medieval (around 1500–1700).
Discovered in 2004 near Longford, Derbyshire.
Derby Museum and Art Gallery.

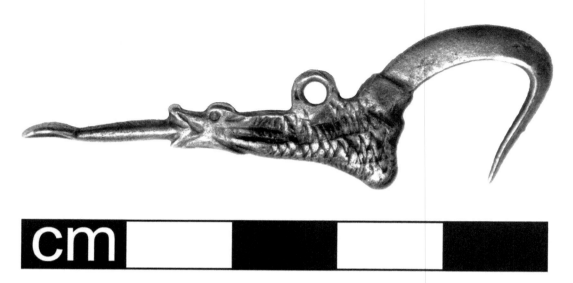

Toothpick and earscoop pendant.

Toothpick pendants became popular accessories in the late sixteenth century. This silver one is shaped to represent a stylised dragon, with a long straight tongue with a spoon bowl at the end that served as an earscoop. At the other end is a crescent-shaped spike that would have been used as a toothpick.

**42. Posy ring (DENO-FD1D98)**
Post-Medieval (around AD 1550–1650).
Discovered in 2008 in Erewash, Derbyshire.
Erewash Museum.

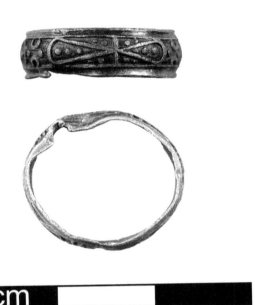 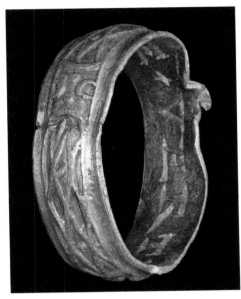

*Left*: Posy ring.

*Right*: Posy ring. (Image courtesy of Erewash Museum)

A posy is a motto or line of verse inscribed on a ring. These rings were popular gifts between lovers during the sixteenth and seventeenth centuries and, as a result, they are one of the most common object types to be classed as Treasure under the Treasure Act 1996. The vast majority of posy rings are made of gold, but this one is made of silver and is decorated with gilding. Presumably this ring belonged to or was given by someone who could not afford a gold ring, and perhaps the gilding was an attempt to conceal this fact. The inscription on the inner surface of the hoop reads 'VSE VIRTVE'. The short inscription and the use of capital letters help to date this ring to the late sixteenth century or early seventeenth century. At least fourteen other posy rings have been discovered in Derbyshire and Nottinghamshire. Inscriptions on them include:

   '*I LIKE MI CHOIES*' (DENO-EC60B2)
   'Your frend till death' (DENO-5FA2D0)
   'Let no callamitie seperat amitie' (CAM-658F86)
   'As I Say So Will I doe' (DENO-655D65)
   'If love can merrit I shall inherit' (DENO-353213)

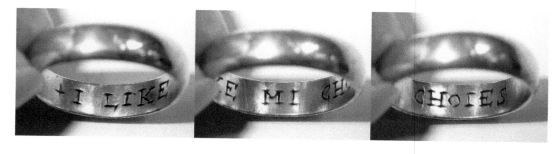

Another gilded silver posy ring from Mercaston, Derbyshire (DENO-EC60B2).

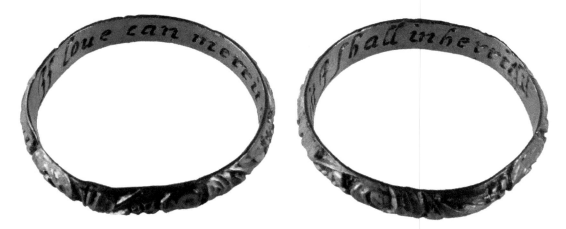

Posy rings are more commonly made of gold, such as this example from Staythorpe, Nottinghamshire (DENO-353213).

**43. Hoard of silver coin clippings (DENO-789371)**
Post-Medieval (AD 1558–1649).
Discovered in 2012 near Milthorpe, Derbyshire.
Fitzwilliam Museum.

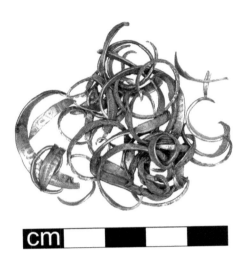

Hoard of coin clippings.

Coin-clipping was the act of removing the edges of precious metal coins with the intention of melting them down to make counterfeit coins. It was fairly common practice during the medieval and post-medieval periods, despite execution being one of the possible penalties if caught doing so. Many of the medieval coins that are discovered by metal detectorists have been clipped. Coin clipping became even more frequent during the English Civil War, when it became much easier for criminals to escape justice. As a result, a number of hoards of coin clippings have been discovered from this period. This particular hoard contains clippings from coins of Elizabeth I, James I and Charles I, most of which are silver shillings.

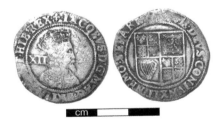

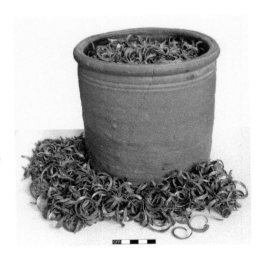

*Above*: Many of the clippings are from shillings of James I, similar to this example from Perlethorpe (DENO-E12357).

*Right*: A different hoard of clippings and the pot it was found in, discovered at Alderwasley in 1971. (Derby Museums Trust)

## 44. Finger rings (e.g. DENO-936193)
Post-Medieval (around AD 1600-1700).
Discovered in 2014 in Kelham, Nottinghamshire.

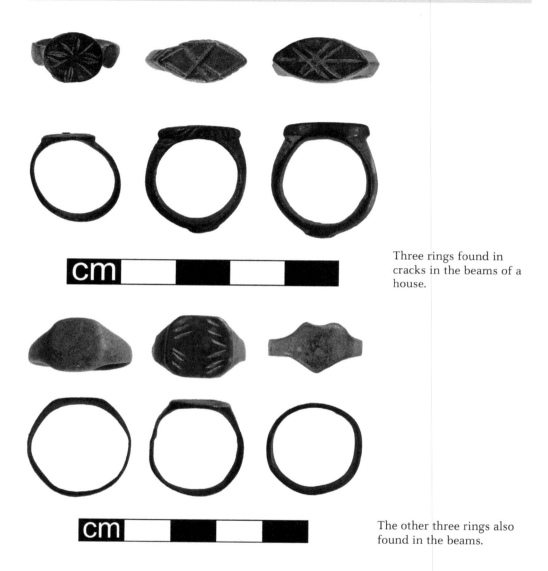

Three rings found in cracks in the beams of a house.

The other three rings also found in the beams.

These copper-alloy finger rings were all found hidden in cracks in the beams of a house. The house dates to the late sixteenth century and is located next to the site of an old blacksmith's workshop, which appears to have been in use during the English Civil War. Perhaps the rings were hidden away for safe keeping during the war or perhaps they were left in the beams as part of some superstitious ritual. The rings can only be dated by style to the fifteenth to seventeenth centuries, but their findspot within a late-sixteenth-century house indicates that they are unlikely to have been made much earlier than that.

## 45. Container made from jettons (DENO-DC0684)
Post-Medieval (around AD 1612–1700).
Discovered in 2014 near Barlborough, Derbyshire.

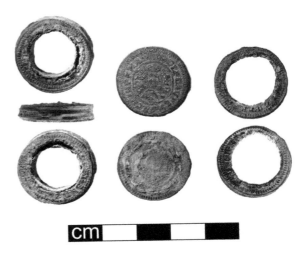

Container made from jettons.

Jettons were copper-alloy accountancy tokens or 'casting counters' (from the French *jeter*, meaning 'to throw'), used for calculating large sums when numerals were still written using the Roman system. Jettons were usually minted in Nuremberg in Germany or Tournai in France and were exported in large numbers. They are found in such large quantities that it is thought they were used as very low-value coinage, during a period when the state was not producing enough small denomination coins. This box is made from ten jettons, nine of which have a wide, roughly circular hole cut through their middles. These nine are held together by a ferrous material. The tenth jetton is complete and appears to have formed a lid. With the lid on, the container would have appeared to be a stack of jettons, so it seems likely that the container concealed something of value.

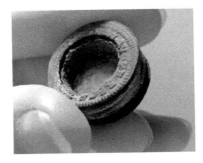 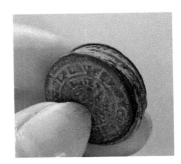

*Left*: The jettons pieced back together.

*Right*: The complete jetton forming the lid of the container was issued by Wolf Laufer in Nuremberg between 1612 and 1651.

**46. Lead shot and iron cannonballs (e.g. DENO-93210E and DENO-D6BF2B)**
Post-Medieval (probably AD *c.* 1644–1646).
Discovered between 2008 and 2015 in Kelham, Nottinghamshire.

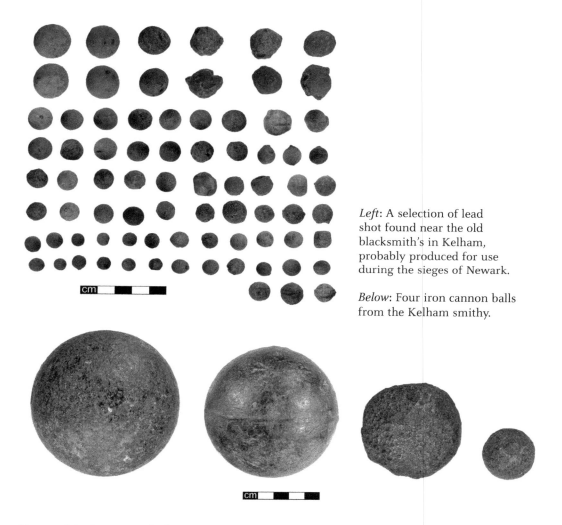

*Left*: A selection of lead shot found near the old blacksmith's in Kelham, probably produced for use during the sieges of Newark.

*Below*: Four iron cannon balls from the Kelham smithy.

Unsurprisingly, cannonballs and lead shot are frequently found in and around Newark, which was besieged three times during the English Civil War. This particular group was discovered in the back garden of a late-sixteenth- or seventeenth-century house in Kelham, next to the site of a blacksmith's workshop of the same date. Kelham was Parliamentarian and occupied by the 'Scottish Army'; it is highly likely that these cannonballs and lead shot were produced for use against the Royalist defenders of Newark. The types of firearms and cannons varied considerably because military units were expected to obtain their own firearms and bore standardisation did not occur until the eighteenth century. As a result, all the lead shot and cannonballs from this group are of different sizes.

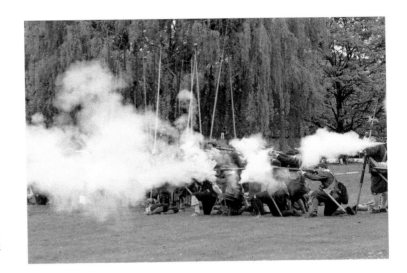

Re-enactors dressed as Civil War period musketeers, firing a volley. (National Civil War Centre – Newark Museum).

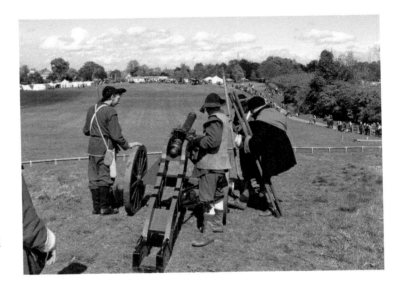

Re-enactors dressed as Royalists, preparing to fire a small cannon from the Queen's Sconce. (National Civil War Centre – Newark Museum)

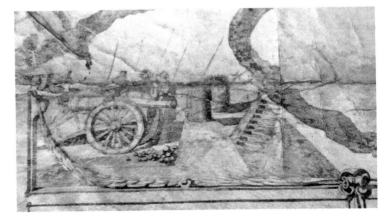

Detail from a Royalist siege map of Newark's defences dating to 1646, showing a gun emplacement with gabions protecting the gun and its crew. (National Civil War Centre – Newark Museum, image taken by Doug Jackson)

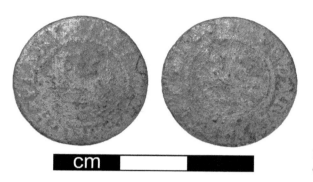

Halfpenny token of the Shallcross colliery.

It was common practice in the late seventeenth century for companies and individual tradesmen to mint their own copper-alloy currency to give as small change for their customers and as payment to their workers. This was a result of an increase in the number of cash transactions and an insufficiency of low-denomination coinage from the state. As these tokens were not official currency, it is likely that people were only able to use them to pay for goods at the place they received the tokens in the first place, or shops belonging to the issuers. Few colliery owners produced their own tokens and, as such, they are relatively unusual compared to other traders' tokens. This token travelled some distance from the Shallcross colliery in High Peak, Derbyshire. The token was probably issued by Richard Shallcross, the Bailiff of High Peak, who, as landowner, owned the rights to the coal. The coat of arms of the Shallcross family appears on the obverse, while the reverse shows the family crest – a martlet carrying a cross in its beak. The inscription reads, 'COLE MINES HIGH PEAKE IN DARBY-SHEIRE'.

*Above*: Illustration showing details originally on the Shallcross token, many of which have worn away. (Illustration by Lucy Young)

*Right*: Coal mining remained an important industry in both counties until recently. This is Clipstone Colliery, completed in 1953 and closed in 2003. (© Lucy Young 2016)

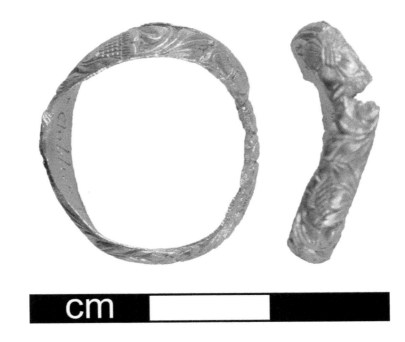

Memorial ring.

While many rings were given as tokens of love or as symbols of marriage, some rings were worn to remember loved ones. This gold memorial ring is inscribed, 'H.T. the Glory of her Children obt: 85: aeta: 68'. The inscription indicates that the woman commemorated died in 1685 at the age of 68, and that the ring was commissioned by her children.

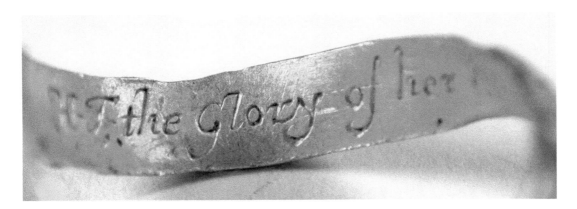

Part of the inscription on the memorial ring.

## 49. Baltic bale seals (e.g. DENO-2AB090)
Post-Medieval (AD 1790–1799).
Discovered in 2004 in Retford.

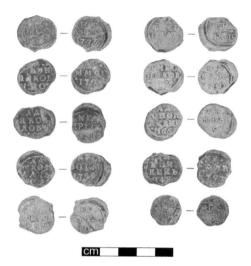

Group of Baltic bale seals.

Russia exported large quantities of flax and hemp during the late eighteenth and early nineteenth centuries, much of it bought by Britain for turning into cloth. Archaeological evidence for this trade consists of lead bale seals stamped with Cyrillic inscriptions, which were attached to bales of flax and hemp, to guarantee their quality. So far more than 250 have been recorded with the PAS. Many of them were found near to coastal ports or along the banks of major rivers, reflecting how rivers continued to be used as important trade routes for inland towns. This group of ten seals was found in a field next to the River Idle, just outside Retford. The River Idle is one of the Trent's tributaries but, because the Idle was not navigable this far upriver, it is more likely that the Russian flax bales were being brought up the newly opened Chesterfield Canal. It was common practice for the unusable parts of the flax (including the bale seals) to be added to night soil and spread on fields as fertiliser, thus explaining their location. Most of the seals found at Retford date to the 1890s and are stamped with NP or WK on the reverse, indicating that they were attached to bales of flax rather than hemp. The rest of the inscription on the reverse reveals the initials of the grower of the flax, the number of flax heads in the bale and the date of the inspection. The obverse inscription has the initials and name of the inspector and his post number.

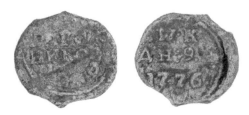

One of the Baltic bale seals, dating to 1776.

90

## 50. Fake Scarborough Siege Piece (DENO-DB4ADD)
Late Post-Medieval to Modern (around AD 1850–1950).
Discovered in the 1960s in Newark, Nottinghamshire.
On loan to National Civil War Centre – Newark Museum.

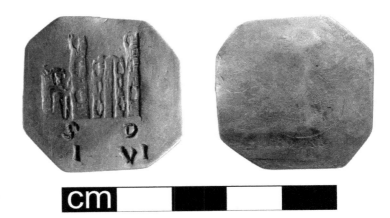

Fake Scarborough siege
token.

This is a Victorian or modern copy of a Scarborough siege piece. Real siege pieces are very rare coins that were produced in towns under siege during the English Civil Wars in order to pay soldiers and maintain a semblance of normal life. They were made from chopped-up pieces of silver plate and stamped with their value. This example, found in Newark, is stamped with a depiction of Scarborough castle with the value beneath. The reverse is inscribed 'Scarborough 1645'. Siege pieces became popular souvenirs and were frequently copied during the nineteenth and early twentieth centuries. What gives this example away as a copy is that the stamp of the castle is identical to that of a known copy made using a Victorian florin.

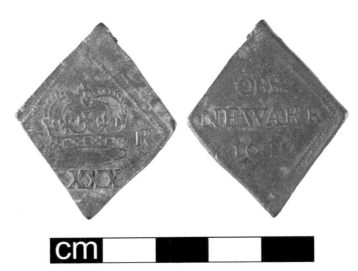

A comparable fake Newark
siege token (WMID-FA6147).

# Conclusion

The artefacts included in this book represent a small fraction of the objects that have been recorded from Derbyshire and Nottinghamshire on the PAS database. Individually, they are among the more interesting and beautiful objects from the area and demonstrate well the role played by the two counties throughout human history. Nevertheless, the more common, less attractive objects and coins that are not included here are just as important for understanding how the people of the region lived in the past. For this reason, it is vital that people who have discovered objects bring them in for recording.

For more information about the PAS, Treasure, conservation and responsible metal detecting please visit www.finds.org.uk.

Members of the public learning how to identify Roman coins at a PAS event at Derby Museum. (© Lucy Young)

# Further Reading

General Archaeology

Adkins, Roy, Adkins, Lesley and Leitch, Victoria, *The Handbook of British Archaeology* (London: Constable and Robinson Ltd, 2008).

Bateman, Thomas, *A Descriptive Catalogue of the Antiquities and Miscellaneous Objects Preserved in the Museum of Thomas Bateman at Lomberdale House, Derbyshire*, (Bakewell, Thomas Bateman, 1855).

Cooper, Nicholas J. (ed.), *The Archaeology of the East Midlands: An Archaeological Resources Assessment and Research Agenda*, Leicester Archaeology Monograph 13 (Leicester: University of Leicester Archaeological Services, 2006).

Howarth, E., *Catalogue of the Bateman Collection of Antiquities in Sheffield Public Museum* (London: Dulau and Co., 1899)

Knight, David and Howard, Andy J. (eds), *Trent Valley Landscapes: The Archaeology of 500,000 Years of Change* (King's Lynn: Heritage Marketing and Publications Ltd, 2004).

Knight, David, Vyner, Blaise and Allen, Carol, *East Midlands Heritage: An Updated Research Agenda and Strategy for the Historic Environment of the East Midlands* (Nottingham: The University of Nottingham, 2012).

Prehistory

Billingsley, John, *Stony Gaze* (Capall Bann Publishing: Chieveley, 1998)

Budge, David and Robinson, Chris, *Stone Age Nottinghamshire* (Nottingham: Nottinghamshire Couty Council, 2011).

Butler, Chris, *Prehistoric Flintwork* (Stroud; Tempus Publishing Ltd, 2005).

Davis, Richard, 'The Tuxford Hoard: an Important Metal Detectorist Find from Nottinghamshire', *Transactions of the Thoroton Society: The Journal for Nottinghamshire History and Archaeology*, Vol. 18, 2014, pp. 31–38 (Nottingham: Thoroton Society, 2014).

Davis, Richard, *The Late Bronze Age spearheads of Britain*. Prähistorische Bronzefunde V, 7 (Stuttgart: Franz Steiner Verlag, 2015).

## Roman

Daubney, Adam, 'The cult of Totatis: Evidence for tribal identity in mid Roman Britain' in *A Decade of Discovery: Proceedings of the Portable Antiquities Scheme Conference 2007*, (eds.) S. Worrell, G. Egan, J. Naylor, K. Leahy & M. Lewis, British Archaeological Reports, British Series No.520, pp. 109–120 (Oxford: Archaeopress, 2010).

Moorhead, Sam, *A History of Roman Coinage in Britain* (Witham: Greenlight Publishing, 2013)

Palfreyman, Alan and Ebbins Susan, 'Excavation at a suspected Roman villa at Heage, Derbyshire 2011–2013', in *Derbyshire Archaeological Journal*, Vol. 132 (Derby: Derbyshire Archaeological Society: 2015).

Patterson, mark, *Roman Nottinghamshire* (Nottingham: Five Leaves Publications, 2011).

## Early-Medieval

North, J. J., *English Hammered Coinage: Volume 1: Early Anglo-Saxon – Henry III, c. 650 – 1272* (London: Spink & Son Ltd, 1963).

Thomas, Gabor, *Late Anglo-Saxon and Viking strap-ends 750–1100: Part 1*, Datasheet 32 (Sleaford: Finds Research Group AD700-1700, 2003).

## Medieval

Mernick, Philip and Algar, David, 'Jettons and Casting Counters', in P. Saunders (ed.) *Salisbury Museum Medieval Catalogue, Part 3*, pp. 213–260 (Salisbury: Salisbury and South Wiltshire Museum, 2001)

## Post-Medieval

Thompson, R. H., *Sylloge of Coins of the British Isles: 31, The Norweb Collection, Cleveland, Ohio, U.S.A.: Tokens of the British Isles, 1575–1750, Part I: England: Bedfordshire to Devon* (London: Spink & Son Limited, 1984).

# The Portable Antiquities Scheme

The Portable Antiquities Scheme (PAS) was first established in 1997 as a pilot scheme following the introduction of The Treasure Act 1996. Since then, it has grown to a national project comprising a team of over forty Finds Liaison Officers (FLOs) and National Finds Advisers covering both England and Wales. The core role of the PAS is to record and identify archaeological objects found by the public. Anyone can discover an object, whether intentionally through metal detecting or accidentally while gardening. These finds fill the gap between known historic sites and provide an important insight into rural, non-elite sites that have often been overlooked by traditional archaeological methods. Through recording these finds we not only gather knowledge of the objects themselves but also of the landscape to which they belong. FLOs also work closely with coroners to help administer The Treasure Act, which gives museums the opportunity to acquire significant artefacts and preserve them for future generations.

In the East Midlands the PAS is represented by five Finds Liaison Officers covering the following areas: Derbyshire and Nottinghamshire; Lincolnshire; North Lincolnshire; Leicestershire and Rutland; Northamptonshire. The FLOs meet finders through individual appointments, at finds days in museums and by visiting metal detecting clubs. Outreach days and talks at local societies are also held to promote the scheme as a research and education tool. The PAS has recorded over a million objects and continues to record hundreds of finds every week thanks to active participation and engagement with members of the public. Once recorded on our database (www.finds.org.uk/database) these finds are used in research by professional archaeologists, university students and school children, providing a vital means of expanding our knowledge of the past.

For more information about the PAS in Derbyshire and Nottinghamshire, visit:
https://finds.org.uk/counties/derbyshire/
https://finds.org.uk/counties/nottinghamshire/
www.facebook.com/DerbysNottsPAS

# About the Author

Alastair Willis has worked for the Portable Antiquities Scheme since 2013. He became the Finds Liaison Officer for Derbyshire and Nottinghamshire in 2015. He is employed by Derby Museums Trust and is normally based at Derby Museum and Art Gallery, though he also regularly works in Nottingham. Alastair studied Ancient History and Archaeology at the University of Bristol before completing a Master's in Egyptology at the University of Liverpool. Alastair deals with objects of all periods up to 1700, and is especially interested in the Roman period.

## DERBY MUSEUMS

A WHOLE HISTORY OF FORWARD THINKING

Alastair Willis. Finds Liaison Officer for Derbyshire and Nottinghamshire.